*Latin Psalter Manuscripts in
Trinity College Dublin and the Chester Beatty Library*

Latin Psalter Manuscripts
in Trinity College Dublin
and the Chester Beatty Library

Laura Cleaver *and* Helen Conrad O'Briain

FOUR COURTS PRESS

Typeset in 11pt on 14pt Centaur by
Carrigboy Typesetting Services for
FOUR COURTS PRESS LTD
7 Malpas Street, Dublin 8, Ireland
www.fourcourtspress.ie
and in North America for
FOUR COURTS PRESS
c/o ISBS, 920 NE 58th Avenue, Suite 300, Portland, OR 97213.

© the authors and Four Courts Press 2015

A catalogue record for this title is available
from the British Library.

ISBN 978–1–84682–560–6

All rights reserved.
Without limiting the rights under copyright
reserved alone, no part of this publication may be
reproduced, stored in or introduced into a retrieval system,
or transmitted, in any form or by any means (electronic, mechanical,
photocopying, recording or otherwise), without the prior
written permission of both the copyright owner and
publisher of this book.

Printed in Spain
by Grafo, S.A.

Contents

Acknowledgments . 11

Foreword . 13

The Book of Psalms or Psalter *Helen Conrad O'Briain* 15

Illustrating the Psalter *Laura Cleaver* . 23

The Library Collections: Patronage and Provenance *Laura Cleaver* 39

THE CATALOGUE OF MANUSCRIPTS . 51

Glossary . 97

Bibliography . 101

For our families and cats

Dublin Studies in Medieval and Renaissance Literature

SERIES EDITOR John Scattergood

This series of critical and interpretative books seeks to address significant aspects of medieval and renaissance literature mainly in English, but also literature in the other European vernaculars important at the period, or in Latin. It will include studies of important single texts, major authors and broad movements. It is intended to include both monographs and collections of essays on specifically articulated topics. The focus of the series will be on studies which foster an understanding of literary texts in terms of their relationships to those aspects of contemporary history, politics and culture out of which they were produced. The researches of established academics will be made available as will studies by younger scholars. The series will include reviews and revaluations of major aspects of the literature of the period as well as original studies which break new ground or offer fresh approaches to familiar subjects. Studies of primary materials – manuscripts and early printed books – will also be included.

IN THIS SERIES

1. Tony Corbett, *The laity, the Church and the Mystery Plays: a drama of belonging*
2. Dinah Hazell, *Poverty in late Middle English literature: the meene and the riche*
3. Eiléan Ní Chuilleanáin and John Flood (editors), *Heresy and orthodoxy in early English literature, 1350–1680*
4. Carol J. Harvey, *Medieval French miracle plays: seven falsely accused women*
5. Clíodhna Carney and Frances McCormack (editors), *Chaucer's poetry: words, authority and ethics*
6. Robert Adams, *Langland and the Rokele family: the gentry background to Piers Plowman*
7. Laura Cleaver and Helen Conrad O'Briain, *Latin psalter manuscripts in Trinity College Dublin and the Chester Beatty library: sing to the Lord a new song*

Acknowledgments

One of the great pleasures of working on this project has been the chance to learn from others. The authors would like to thank Elizabethanne Boran, Nick Cleaver, Alice Jorgensen, Emma Luker, Kateljine de Meyer, John Scattergood, Laura Slater, Colleen Thomas, Jill Unkel and Andrea Worm for sharing their knowledge and expertise. We are particularly grateful to the staff of the Chester Beatty Library and the Manuscripts and Archives Department of Trinity College Library for making material available and for their great patience. The production of this book would not have been possible without generous grants from the Arts and Social Sciences Benefactions Fund, Trinity College Dublin and the Trinity Irish Art Research Centre.

Foreword

The book of Psalms was at the core of devotional practice in western Christianity throughout the Middle Ages. For this reason the study of medieval Latin Psalters provides evidence for the owners and users of these books as well as their makers. The choices made about text, decoration, size and layout in these books reveal a range of engagements with the Psalms. Our aim in this study has been to address these manuscripts as objects, exploring their text, decoration and physical structure, as well as changes made to them over time. In concentrating on the Psalter as a devotional book we have ignored complete Bibles, in which, of course, the Psalms would be included. We have also excluded Breviaries, Antiphonals, and Books of Hours, in which the Psalms appear as they were used in the medieval liturgy (often in abbreviated form with opening lines as prompts for memorized texts); these manuscripts are worthy of a study in their own right. The manuscripts included here do, however, represent some of the other uses of the Psalms in the Middle Ages, as tools for private reading, devotion, preaching and study, with translation, adaptation and commentary sometimes appearing in addition to the Psalm text. Ferial Psalters with the full Psalm text have been included, even though the text has been adapted for liturgical use. Each of the volumes presented here is unique. Many of these volumes have received minimal attention from scholars, and we hope that the catalogue will encourage further research on these and other treasures in two of Dublin's collections of manuscripts.

The Book of Psalms or Psalter

Helen Conrad O'Briain

The Bible is ubiquitous in western culture. Changes in belief and practice may have made it less familiar today, but it is so deeply embedded in the development of western thought and art, even the actively irreligious cannot avoid its influence. Within the Bible, the Book of Psalms, or Psalter, is perhaps the most influential book of this influential work and a microcosm of the Bible as a whole. Its poetry of praise, thanksgiving and supplication recapitulates Old Testament history, prophecy, and moral exhortation. It is the prayer book of two faiths, the primer of generations of readers, a gateway text into literary theory as well as theology/spirituality. In the Old Irish poem *An chríonóc cubaid do cheól*, it is a wise, womanly, teacher and companion. The first book of the Bible regularly read by members of the laity, it developed their sensitivity to biblical style and methods of reading. The Psalms prepared them for reading the Bible as a whole and affected not only their further reading and their writing, but the formation of their inner life.

Despite, or perhaps because of, its ubiquity and fundamental importance, the Psalter has at times been at the centre of bitter disagreements, not the least over the perceived Christian appropriation of a fundamentally Jewish text. In Ireland, in the sixth century, Columba's clandestine copying of a Psalter ended in the first copyright battle. *The Bay Psalm Book* (1640), the first book printed in English in the Americas, came into being because of deep dissatisfaction with other translations. The history of the Psalter is full of wrangling over the meaning of individual psalms, the identity of its author or authors, even the Psalms' division and numbering with the Septuagint (the earliest translation of the Psalms into Greek) and Hebrew versions numbering the Psalms as follows:

Septuagint	Hebrew
1–8	1–8
9	9–10
10–112	11–113
113	114–15
114–15	116
116–45	117–46
146–7	147
148–50	148–50

The Vulgate translation of the Psalms into Latin followed the Septuagint numbering. The numbering is important when reading any discussion of the Psalms. As recently as 2006 reporters failed to distinguish between Vulgate and Masoretic (the standard Hebrew text) numbering when reporting on the discovery of the Faddan More Psalter, found open at Psalm 83 in the Vulgate/Septuagint numbering, inadvertently causing a minor international incident when some members of the press confused the two numberings and assumed there was an implicit divine warning to the state of Israel. What exactly is the difference between the two methods of numbering? As we can see from the table above, the two versions differ in where they divide one psalm from another. Clearly we are looking back to a very early moment in the collection's history when there was not sufficient physical division between the texts to be certain of authorial or editorial intent. The Vulgate, the Douai-Rheims translation into English and medieval scholars follow the numbering in the Septuagint while the King James version and biblical scholarship follow the Hebrew (Masoretic). Medievalists use the Vulgate numbering because the Vulgate represents the Bible as known and used in the European Middle Ages, but even here one must be careful, for there were different Latin translations of the Psalms in use in late antiquity and throughout the Middle Ages.

The Historical Development of the Psalter

Like the Bible itself, the Psalms did not suddenly come into being as a self-contained collection. The fourth-century scholar Saint Jerome writes frankly of the problems both Rabbinical and Christian scholars had in making fundamental decisions about the book. Neither Rabbinical nor

Patristic authorities agreed among themselves on the authorship of the Psalms or how many 'books' or divisions were in it. While Jerome insisted on an undivided book, some writers suggested a five- or eight-fold division; the Irish usually speaking of the 'three fifties'. In Qumran we have the remains of a scroll containing canonical Psalms, biblical canticles and otherwise unknown Psalms. It cannot be said for certain whether this text should be interpreted as a Psalter or as a collection of sacred song drawing on a Book of Psalms the same or different from that which lies behind the Masoretic and Septuagint text.

In the Jewish tradition the Psalms are part of the Writings, the third division of Scriptures (the other two are the Law and the Prophets). Described by some scholars as the hymnal of the Second Temple, certainly as a genre, and in many cases individually, they reach back to the period of the First Temple and earlier. Traditionally David is their author, but while he is so identified in a number of them, the *tituli* (titles) of some Psalms suggest other authors, for example Solomon (Psalms 72 and 127) and Asaph (Psalms 72–82). The appearance of passages like Hannah's Psalm in 1 Samuel suggest the importance of the Psalm as a genre in the culture of Israel; the great canticles of the New Testament, the *Benedictus*, *Magnificat* and *Nunc dimittis*, would be unimaginable without that tradition.

Our earliest extant manuscript of the Psalms comes from Qumran, as part of the Dead Sea Scrolls. Dated to the last century before the Common Era (BCE), the texts of the Psalms still present in the now canonical Book of Psalms are extremely close to the Masoretic text. There are places where the order of the Psalms is different and other biblical Psalms including the so-called Psalm 151, a text which while belonging to the psalm genre has never been accepted as part of the Book of Psalms, are included. Psalm 151 continued, in fact, to appear sporadically in manuscripts until quite late (for example in the twelfth-century Winchcombe Psalter, Trinity College Library MS 53), although it was never used liturgically.

Translations and Translating

The Psalms were composed in Hebrew, but with the Jewish diaspora moving into Aramaic- and, later, Greek-speaking lands after the destruction of the First Temple, translations arose for the use of observant

Jews whose daily language was no longer Hebrew – and certainly not the poetic, courtly language of the Psalms. The Aramaic paraphrase, translations or *Targum* must be passed over here. For the western tradition, the translations into Greek are crucial; they are not only the text used by the Greek Fathers and remain the basis of the Greek Bible, but they were the source of the first Latin Bible of the West, the *Vetus Latina*. In the last centuries BCE translations of Law, Prophets and Writings were made into Greek. Although the text probably represents more than one act of translation, the Greek translation called the Septuagint is traditionally credited to seventy Jewish scholars (hence Septuagint, meaning seventy) sent to Alexandria at the request of Ptolemy Philadelphus to produce a Greek version for his library at Alexandria. Over the centuries this translation achieved an almost divinely sanctioned status. The Septuagint is still the Old Testament of the Greek-speaking churches and, with the Hebrew text, lies behind both the Latin Vulgate text of the Old Testament as well as modern editions and translations. Indeed, until the Qumran texts were discovered (beginning in 1947), Septuagint Old Testament manuscripts predated manuscripts of the Masoretic text by centuries, and Jewish scholars used early Septuagint manuscripts in the process of editing the Hebrew.

Outside certain trading centres and social classes, the knowledge of Greek was limited in the western half of the Roman Empire. As Christianity spread there, it increasingly became Latin speaking. By the late second century, western Christians were translating the Septuagint as well as the New Testament into Latin. There is little consensus on when and by whom, or even how often, this was done, but in general we can speak of the Latin Bible that circulated and is quoted by the North African Fathers Cyprian and Tertullian as the *Vetus Latina*, or Old Latin version. It was a translation lacking literary pretensions, erring on the side of the literal (readers focused on the potential of meaning in every word and idiom would have been uncomfortable with anything else), but at times misleading and simply incorrect. It was, however, the Bible the western Christian knew and for which people had died rather than hand over in the last great persecution of Christians *c.*300 CE. Jerome's translation, the Vulgate, now celebrated for its majestic Latin, was actually to an educated, native Latin speaker, just that, vulgar, not in the modern sense, but in the

sense of closer to everyday speech. Jerome himself was acutely aware of the difficulties of translating. He moved between the literal and the sense. He spoke too of the difficulty of conveying the grace and dignity of the text particularly the poetry of the Psalms and the urbanity of Isaiah, 'whose language' he wrote in his preface to *Isaiah* 'has no taint of rusticity'.

It is obvious Christians and Jews not only read the Psalms differently, but that among both communities readings have evolved over time. In the following, the approach we attempt to describe is that which produced the Psalm manuscript texts held by the Trinity College and the Chester Beatty libraries. The Apostolic and sub-Apostolic writers had used the book largely for proof texts demonstrating that Jesus was indeed the promised Christ, much as Jesus himself did in the Gospels. As late as the early fifth century, Jerome cited such use as a reason for providing a translation directly from the Hebrew. It is easy enough for modern readers to pick out Psalm passages which have a moral/wisdom content or recapitulate the history of the chosen people, less easy to understand how they might all, for some readers, relate directly to Christ, but when Handel used Psalm texts in *The Messiah* he was working in the ancient Christian tradition of reading the Psalms as Christological prophecy.

The various series of *tituli* accompanying the individual Psalms in many medieval manuscripts include brief directions to the reader to understand individual Psalms in reference to Christ's voice or the voice of the Church. Although extremely short, *tituli* punch above their weight theologically. By the end of the fourth century, however, the Psalms were also a lynchpin of Christian worship, increasingly important with the development of the *officia Dei*. This alone ensured the Psalter was one of the first books of the Old Latin Bible Jerome revised. This revision was not universally welcomed; anyone who recalls the introduction of the English Mass or the revision of the *Book of Common Prayer* can imagine the reaction. Jerome's first attempt to produce an acceptable Psalter, the Romanum, was a revision of the *Vetus Latina* in reference to the Septuagint. This text is important for Anglo-Saxon England and for the history of the Roman Breviary. Almost immediately after the production of the Romanum version Jerome retranslated the Psalms directly from the Septuagint. This is known as the Gallican version, as it was popular with the French 'Gallican' churches, and was the standard Psalter of the Irish

after the sixth century at the latest (the late sixth- or early seventh-century *Cathach* in the Royal Irish Academy, Dublin, has a good Gallican text retaining Jerome's editorial symbols) and the usual Psalter of the Middle Ages. Finally Jerome translated the Psalms directly from the Hebrew using what was probably an early Masoretic or proto-Masoretic text as well as consulting Rabbinical scholars. This is the Hebraicum version, the medieval scholar's Psalm text. In the eleventh-century Ricemarch Psalter (Trinity College Library MS 50), a verse plays on this idea of three – David's three vocations as prophet, poet and king/warrior, Jerome's three translations and finally the three brothers: Ithial who wrote the manuscript, John who decorated it and Ricemarch for whom they produced it.

The Importance of the Psalter to Latin Literacy and to Christian Prayer

Michael Lapidge gives us a good idea of the immersion in the Psalms children and young men and women of the Early Middle Ages entering the monastic life expected.

> From the outset he was expected to participate in the Divine Office, even though at first he would not have been able to understand a word. Since the Office consists almost entirely of psalmody and hymnody, the beginner would have first committed the Latin psalter to memory. His teacher would have aided memorization by means of literal explanations [...]. By the time [he or she had done so] the young student was ready for the rules of Latin grammar.[1]

In his seminal study of lay literacy in the Middle Ages, James W. Thompson treats the ability to read the Psalms as the *sine qua non* of Latin literacy. For him, as arguably for the contemporary medieval writers he quotes, it represents basic Latin literacy. The late twelfth-century Leiden Psalter (Leiden University Library MS BPL 76a) has an added note claiming that it once belonged to Saint Louis, king of France, who had

[1] M. Lapidge, 'Anglo-Latin Literature' in S.B. Greenfield and D.G. Calder (eds), *A New Critical History of Old English Literature* (New York and London, 1986), pp 5–6.

learned to read from it in childhood. Louis may have received some of his education from his highly educated mother, Blanche of Castile, and many medieval Psalters seem to have been owned by women, albeit only nuns and those of the highest strata of society. The Psalters described in this book represent the centrality of the Psalms to private and liturgical prayer and to literacy. They are all well- or relatively well-written manuscripts, preserving good text traditions. They do demonstrate what a classicist may consider non-standard orthography, but readings like *nichil* (rather than nihil), *ammabile* (rather than *amabile*), *exurge* for *exsurge* (a little more unusual) and the reduction of ae to e are entirely normal for their provenances and dates. This is not to say they do not have mistakes. The scribe of Trinity College Library MS 90 is often less than careful, but is capable of clever corrections. The scribe of the Winchcombe Psalter (Trinity College Library MS 53) cannot keep the Gallican and Hebraicum versions separate in his mind when copying the opening of the first Psalm, *Beatus vir* – one of the more embarrassing mistakes we shall see. Much is made in the literature of the *tituli* of the Psalms, the brief directions and ascriptions to authors given before the Psalm proper, but they are remarkable by their absence in many of our Psalters. It may be that their place at the beginning of literacy and their intimate connection with the liturgy meant that such written direction was largely unnecessary to the intended or expected reader. The readers of our manuscripts had a formation in the devout and orthodox reading of the Psalms before these manuscripts were ever put into their hands.

Some of the Psalters in the Trinity College and Chester Beatty collections were produced within the expectation that they would be used not only for private meditation, but liturgically within the various versions of the liturgical hours, particularly increasingly the 'little hours'. The most popular, the Hours of the Virgin, followed the Little Hours for the Dead, the Holy Cross and the Holy Spirit. As these 'Little Hours' became central to lay prayer, specialized, and even personalized, Books of Hours replaced Psalters as the most popular devotional books of the fifteenth century. Nevertheless, the Psalms even within this new prayer setting continued to form the minds and sensibilities and to direct the thought of all literate men and women. Reading the Bible did not begin with the Reformation; that reading cannot be separated from the centuries of reading the Psalter which preceded it.

FURTHER READING

A. Andreoppoulos, A. Casiday & C. Harrison (eds), *Meditations of the Heart: The Psalms in Early Christian Thought and Practice*, Studia Traditionis Theologiae 8 (Turnhout, 2011).

J. Carney (trans.), *Medieval Irish Lyrics* (Berkeley & Los Angeles, 1967) (*A chrínóc, cubaid do cheól*).

P.R. Davies, G.J. Brooke & P.R. Callaway, *The Complete World of the Dead Sea Scrolls* (London, 2002).

N. van Deusen (ed.), *The Place of the Psalms in the Intellectual Culture of the Middle Ages* (Albany, NY, 1999).

A. Hughes, *Medieval Manuscripts for Mass and Office: A Guide to their Organization and Terminology* (Toronto, 1982, repr. 2004).

J.L. Kugel & R.A. Greer, *Early Biblical Interpretation* (Philadelphia, 1986).

D.J. Ladoucer, *The Latin Psalter: Introduction, Selected Text and Commentary* (London, 2005).

M. Lapidge, 'Anglo-Latin Literature' in S. B. Greenfield & D.G. Calder (eds), *A New Critical History of Old English Literature* (New York and London, 1986), pp 5–37.

M. MacNamara, *The Psalms in the Early Irish Church* (Sheffield, 2000).

N.F. Marcos, *The Septuagint in Context: Introduction to the Greek Version of the Bible* (trans.) W.G.E. Watson (Atlanta, 2000).

W.E. Plater & H.J. White, *A Grammar of the Vulgate* (Oxford, 1926).

G.O. Simms, *The Psalms in the Days of Saint Columba: The Story of the Cathach 'the Battle Psalter'* (Dublin, 1963).

B. Smalley, *The Bible in the Middle Ages*, 3rd edition (Oxford, 1983).

K. Strecker, *Introduction to Medieval Latin* (trans. & rev.) R.B. Palmer (Zurich & Hildesheim, 1999).

J.W. Thompson, *Literacy of the Laity in the Middle Ages* (Berkeley, 1947).

R. Weber (ed.), *Biblia Sacra Iuxta Vulgatam Versionem*, 4th edition emended (Stuttgart, 1994).

R. Weber (ed.), *Le Psautier Romain et les autres anciens psautiers Latins* (Vatican City, 1953).

Illuminating the Psalter

Laura Cleaver

THE PSALMS HAD A SPECIAL PLACE in medieval devotion, and this was often expressed in the visual appearance of Psalters. As songs believed to have been composed by King David, one of Christ's ancestors, and as part of the divinely inspired Biblical text, the Psalms were particularly appropriate texts with which to praise or cry out to God. The Psalms were thus recited in the continual cycle of church services, and copied into books for use in private devotion by church- and lay-men and women. At the same time the text was scrutinized by scholars who understood it both in the context of the Old Testament and as prophesying the coming of Christ. Decoration was sometimes used to help readers navigate the substantial text of the 150 Psalms, to provide frameworks within which the Psalms might be read and meditated upon, and to comment upon the status of this rich text. For those who knew the text well, or by heart, the addition of imagery could prompt a reader to pause and reconsider the familiar words. Decoration in the form of figurative images, swirling foliage, or geometric patterns, thus served to add layers of meaning or significance to the text as well as to stress the status of both the Psalms and the Psalter's owner.

Any Psalter represents an investment of time and materials. Although the visual appearance of Psalters varies dramatically, the process of production remained fairly constant throughout the Middle Ages. If most of the work was undertaken by monks, as was probably the case for the twelfth-century Winchcombe Psalter from the Benedictine house at Winchcombe in England (Trinity College Library MS 53), the labour cost was minimal. The speed at which work progressed would then depend on the number of people between whom the work might be divided up, commitment to the project, as time invested in making a large volume was time not spent on other tasks, and the weather conditions providing suitable light. Intriguingly the decoration of the Winchcombe Psalter seems never to have been completely finished, as the initial to the Hebraicum version of Psalm 101 (in the right-hand column) has been

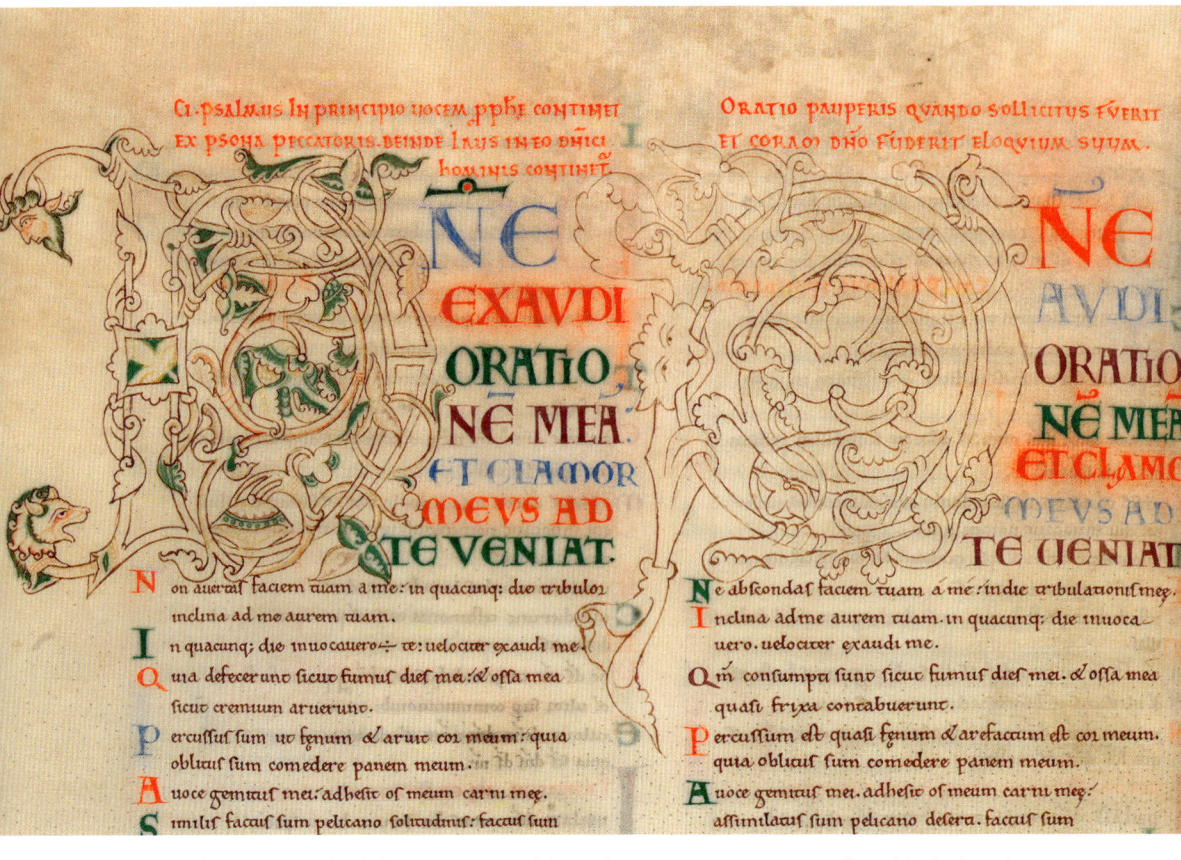

1 Trinity College Library MS 53 f. 178v, detail. © The Board of Trinity College Dublin.

sketched, but not painted (Fig. 1). Decoration was usually added after the text had been completed to prevent it being damaged by scribes. The process of executing a large manuscript (the Winchcombe Psalter also contains the New Testament) could be very time consuming, and thus prone to disruptions caused by the deaths of members of the community or the consequences of local or national political upheavals. The Winchcombe Psalter was probably produced during a period of civil war in the twelfth century. It seems, therefore, that, for reasons now unknown, the Winchcombe monks decided that the Psalter was good enough without the painting of the initial at Psalm 101.

Although some monks were skilled artists, monasteries sometimes employed specialist artists from beyond their own communities to decorate their great books. Thus in the twelfth century the monastery at Bury St Edmunds employed Master Hugo to create the images for their

new Bible. It is rare for the names of craftsmen to be recorded, but the Ricemarch Psalter (Trinity College Library MS 50), produced in Wales *c.*1079, contains verses identifying not only the owner of the volume, Ricemarch, but also Ithael as the scribe and John as the painter of the manuscript. Ricemarch seems thus to have wanted to record the skills of his family and community for posterity. In the Later Middle Ages an increasing demand for books allowed more lay men to establish themselves as specialist scribes or artists. Groups of books with very similar decoration point to individuals and teams of craftsmen, probably based in towns and cities, producing large numbers of Psalters to meet growing demand. The thirteenth-century volume Trinity College Library MS 90, which forms part of a group of books of similar style associated with Liège, is an example of this phenomenon. Such groupings also indicate fashions within book decoration, which were partly fuelled in the Later Middle Ages by the growth of a mercantile class with disposable income. In this period some monks also stretched their monastic vows, which stated that they should not have personal possessions, by owning manuscripts rather than relying on the common resource of the monastic library. These books might be made in monasteries or acquired from elsewhere and could be given to the monastery, another monk or a family member before the monk's death to appease his conscience.

 The production of medieval manuscripts involved a diverse range of processes, and a huge amount of labour. Animal skins had to be transformed into pages with smooth writing surfaces, a process that involved soaking skins in a lime solution or stale urine, stretching and scraping them. In addition to the cost of this labour, as well as the time invested to cut and rule the pages, prepare pens, inks and pigments, write the text, execute any decoration, and bind the finished leaves into a book, the materials themselves could be expensive. The size of the written text and pages, together with the amount of material included, dictated the number of skins required. Thus relatively inexpensive Psalters would typically be small, making use of any parchment available rather than rejecting skins with holes (which could be sewn up or patched if the maker were so inclined), and using pages with irregular edges cut from the peripheries of the skins. The cost of parchment could also be kept down by writing in a small script and leaving only minimal margins to maximize the amount of text on the page. However, small books do not always indicate a lack of resources, as they were also more practical for personal

use, being easier to transport and handle. The intimate scale of the Ricemarch Psalter, at just 160 by 105 mm, may thus have been prompted in part by the fact that it was for Ricemarch's own use, rather than for public reading in a church or refectory, and it has relatively large and clear script, and broad margins. Similarly Trinity College Library MS 10956, made c.1400, measures just 141 by 114 mm, but the contents have been very carefully set out in two columns and the major divisions marked with coloured penwork.

Although decoration could be expensive, careful ruling and marking the start of each Psalm with a slightly larger initial were inexpensive ways to ensure legibility. Among the Psalters in the Dublin collections, Trinity College Library MS 69, a manuscript made in England in the late fourteenth or early fifteenth century, is one of the more modest. Although it measures 200 by 260 mm, the manuscript has narrow margins and up to forty-seven lines of text per page. Nevertheless the scribe has attempted to decorate the Beatus initial (the opening letter of the first word of Psalm one, 'beatus'), using the black ink of the text and the red paint with which he has added the Psalm tituli. Moreover the first word of every Psalm has been marked with a yellow wash and a larger initial letter, helping the reader to navigate the text.

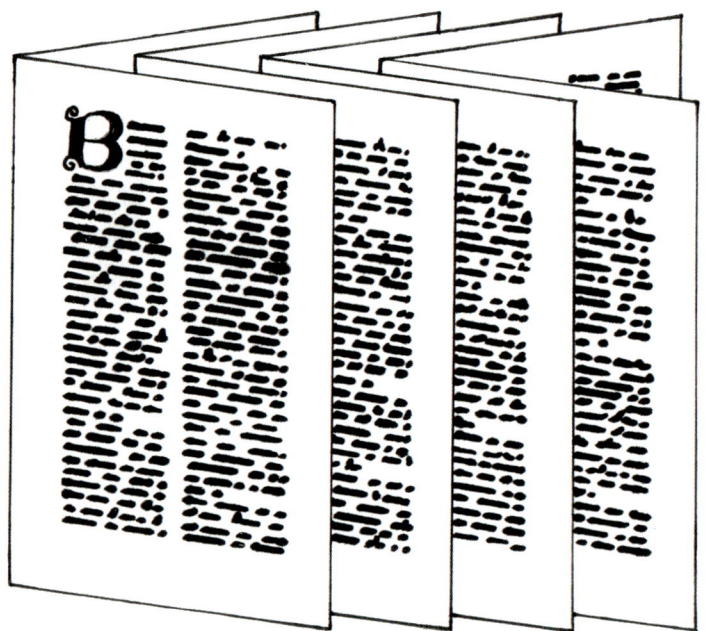

2 The construction of a quire or gathering.

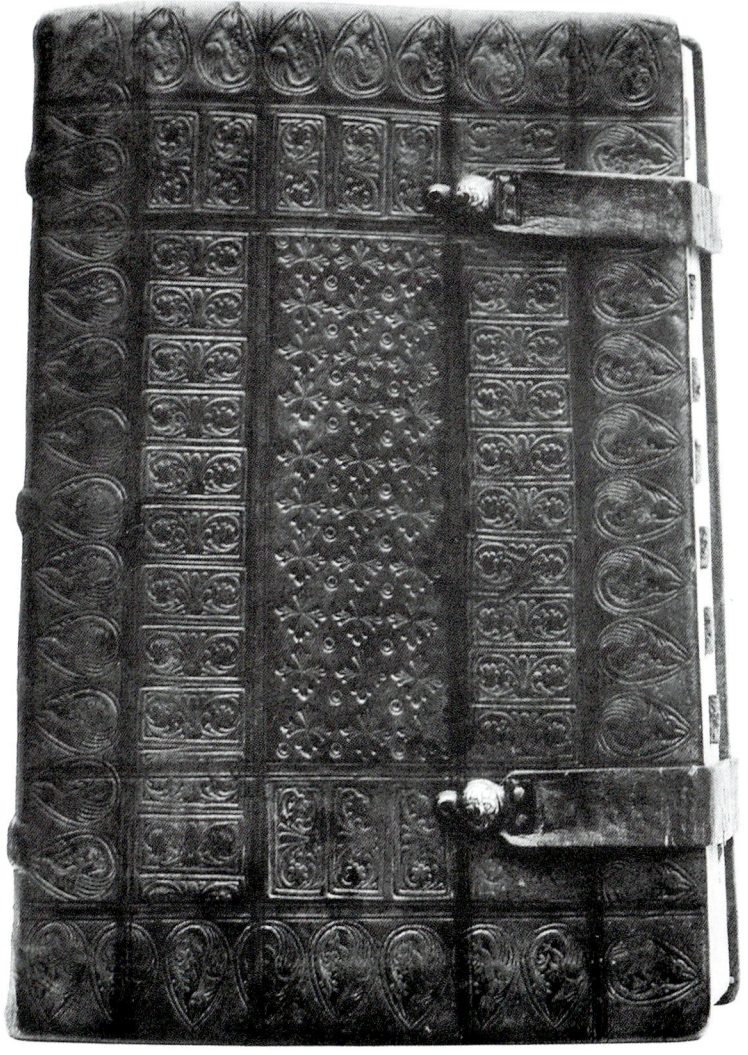

3 Binding of Chester Beatty Library MS W. 40. © The Trustees of the Chester Beatty Library, Dublin.

To provide stability, manuscripts were usually constructed using bifolios, leaves that formed four pages (two on each side) when folded down the middle (Fig. 2). Once all the text and decoration was complete the leaves would be sewn together into groups (known as gatherings or quires), which in turn would be sewn onto supports across the spine to produce a book. Manuscripts were typically completed with wooden covers, covered in leather, which could be decorated. Relatively few manuscripts survive in their original bindings, but Chester Beatty Library MS W. 40 has a fifteenth-century binding of brown leather decorated with

a stamped pattern and completed with two straps that hold the book closed (Fig. 3). Images of personal devotional books in medieval art sometimes show them as being used while placed on, or wrapped in, cloth, which would have provided a further layer of protection for these precious objects.

Most of the surviving Psalters in the Trinity College and Chester Beatty Library collections proclaim a considerable investment of resources in their appearance and decoration, emphasizing the status and value of the religious text. The Winchcombe Psalter measures 430 by 290 mm and its letters are painted with red, blue, green and purple pigments, while manuscripts such as the thirteenth-century volume from Flanders now in the Chester Beatty Library (MS W. 61) have pages dedicated solely to images, many of which contain large areas of gold. The large, eye-catching, volume from Winchcombe probably also served as a status symbol for the community, and other Psalters prominently indicate the status of the men and women for whom they were made through their decoration. Some Psalters, including Trinity College Library MSS 93 and 106, fifteenth-century manuscripts from England and Italy respectively, announce their owners' status through the inclusion of coats of arms, which in both volumes are placed at the start of the Psalm text in the lower margin. In both cases the arms, together with the rest of the page, make use of expensive materials, as the heraldry in MS 93 includes silver, and the example in MS 106 gold. The owners of these books were thus both of high enough rank to have coats of arms and rich enough to include them in their manuscripts.

In addition to the development of some standard decorative schemes for Psalters, wealthy patrons could customize their books to suit their taste. Lay men and women, in particular, may have used additional images to help them make sense of the text (particularly in an age in which literacy in Latin was a specialist skill) and to meditate upon it. Some Psalters were thus provided with cycles of prefatory images that could be studied in conjunction with the Psalms. Cycles such as that in Chester Beatty Library MS W. 61 focused on Christ, emphasizing the Christian interpretation of the text as predicting the life, death and resurrection of Christ. The final image in the sequence shows the crucified Christ surrounded by Old Testament prophets who point to Him. The value of these images is underlined by the decision not to execute images on both

sides of a page, which might cause damage to the first image when the bifolio was turned over to allow work on the back.

In Chester Beatty Library MS W. 61 the historiated initials and other full-page images, which have been inserted as single leaves into the text, continue to emphasize the use of the Psalms in contemporary Christian devotion, featuring images of the saints to whom prayers might be addressed. These include Saints Francis of Assisi and Dominic, who in the early thirteenth century founded monastic orders that became extremely popular, in part due to their emphasis on preaching. In addition, the manuscript includes images of popular saints including Margaret, who was associated with pregnancy and childbirth, and Stephen, the first Christian martyr. Similarly, in Chester Beatty Library MS W. 40, probably produced in Augsburg in the mid-thirteenth century, Saint Francis of Assisi is included in one of the historiated initials, while other initials include a bishop saint, and the archangel Michael. Although the images suggest interest in particular saints on the part of the owner, these could be dictated by patterns of local, rather than individual, devotion, particularly in cities where demand for Psalters led to large-scale production. The expense and importance of some images is further indicated by the inclusion of pieces of silk in Chester Beatty Library MS W. 40, known as curtains, which have been sewn into the book at each initial to protect the images from being damaged by contact with the following page.

Another major theme in images in medieval Psalters explored King David's role as composer of the Psalms. David was widely considered to have composed these songs and thus was frequently represented throughout the Middle Ages with a harp, and sometimes with other instruments. Among the manuscripts in Trinity College and the Chester Beatty libraries, David appears with a harp in the Beatus initials in the Winchcombe Psalter, where he is surrounded by musicians with horns, bells and a viol, and in Trinity College Library MS 93 (f. 2), where he is also shown playing bells in a roundel on folio 1v. On the latter folio the image of David is set opposite an image of a group of men in vestments standing before a lectern on which is an open book, presumably singing the Psalms (Fig. 4). In a variation on the imagery of the harp, David plays a lyre in Chester Beatty Library MS W. 40, and in Trinity College Library MS 106 David plays on a Psaltery, an instrument that, like the term Psalm itself, derives its name from the Greek terms used to describe songs accompanied by stringed instruments.

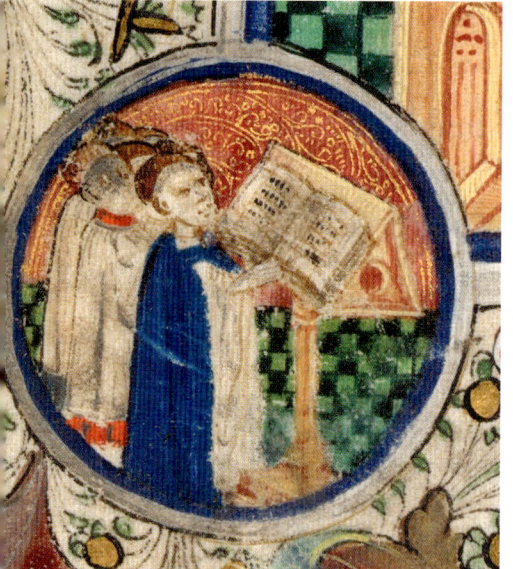 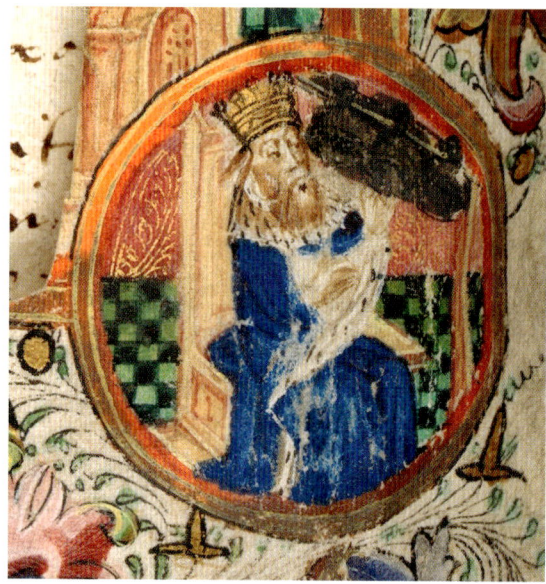

4 Trinity College Library MS 93, details from f. 1v. © The Board of Trinity College Dublin.

Trinity College Library MS 92, produced in England at the end of the fourteenth century, does not include an image of David in its Beatus initial, which instead is filled with swirling foliage. However at Psalm 97, which begins 'sing to the Lord a new song, because he has done wonderful things', a king, who may represent David, but who in his medieval costume prompts an association between the biblical figure and contemporary rulers, has been added to the standard iconography of clerics singing God's praise (Fig. 5). A very similar, although not identical, initial, perhaps designed, though not painted, by the same artist, can be found in another Psalter-Hours now in Edinburgh, National Library of Scotland MS 18.6.5. This serves as a reminder of the importance of the artist, as well as the patron, in informing the content and appearance of images (Fig. 6). In the latter, the decision not to include the image of God at the top of the initial shifts the interpretation of the verse that follows, which begins 'sing to the Lord a new song', focusing attention on temporal, rather than spiritual authority, perhaps representing the views of the artist and/or patron.

Another variation on the theme of David as the composer of the Psalms can be found in the thirteenth-century manuscript produced in France, Trinity College Library MS 91, where David appears in the Beatus initial at a writing desk, in the process of recording the text (Fig. 7). The

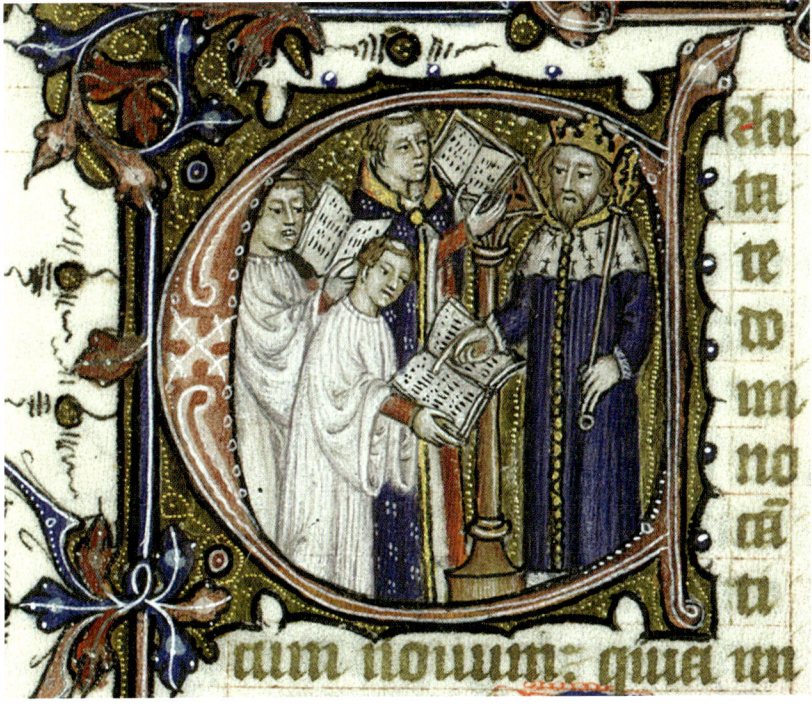

5 Trinity College Library MS 92 f. 69v, detail. © The Board of Trinity College Dublin.

6 National Library of Scotland, MS 18.6.5 f. 109v, detail. © National Library of Scotland.

31

musical associations of the Psalms are not lost, however, as in the margin stands a man carrying a portative organ. This figure is watched both by the lions on the border below and the haloed and winged face that suggests an angel appearing from the decorative border above. A second figure tucked into the inner margin (not visible in the photograph due to the manuscript's tight binding) seems to be dancing, further emphasizing the musical nature of the text.

In addition to providing extra information through images that suggested particular interpretations of the text, decoration could serve the practical purpose of helping a user to navigate the Psalter. Large decorated initials are thus often used to mark out particular Psalms. Both the Ricemarch and Winchcombe Psalters (Trinity College Library MSS 50 and 53) are divided into three parts, with decorated pages and initials respectively at Psalms 1, 51 and 101. The Winchcombe Psalter also has a large initial (although smaller than those at Psalms 1, 51 and 101) for Psalm 109, which was the first Psalm sung at Vespers on Sundays. In Trinity College Library MSS 92 and 93, Psalm 109 is again marked with a painted initial, and the location of the other fully painted initials, on pages that also have decorated borders, indicates that in these Psalters the initials at Psalms 1, 26, 38, 52, 68, 80, and 97 designated the first Psalms to be sung at Matins on each day of the week in the secular liturgy. The eight-part division and three-part division of the Psalms were sometimes combined to form a ten-part division (as Psalm 1 appears in both sequences). This organizational system is adopted in Chester Beatty Library MS W. 40, Trinity College Library MS 90, and Chester Beatty Library MS W. 61. Yet although this decoration resonated with the liturgy of the church, the Psalms only formed part of the services, and from the thirteenth century, Books of Hours that set out the Psalms and prayers to be used at all offices became popular devotional texts. In the Later Middle Ages the two texts were sometimes combined, such that the Psalms in Trinity College Library MS 90 are followed by a version of the Hours, and Trinity College Library MS 92 originally contained both a Psalter and Hours, although most of the Hours has been lost.

The use of Psalters as tools for daily devotion also prompted the inclusion in some volumes of calendars recording the feast days of saints whose help might be sought. Different colours, including gold, were often used to mark out the most important saints' feast days, but the decoration

7 Trinity College Library MS 91 f. 14. © The Board of Trinity College Dublin.

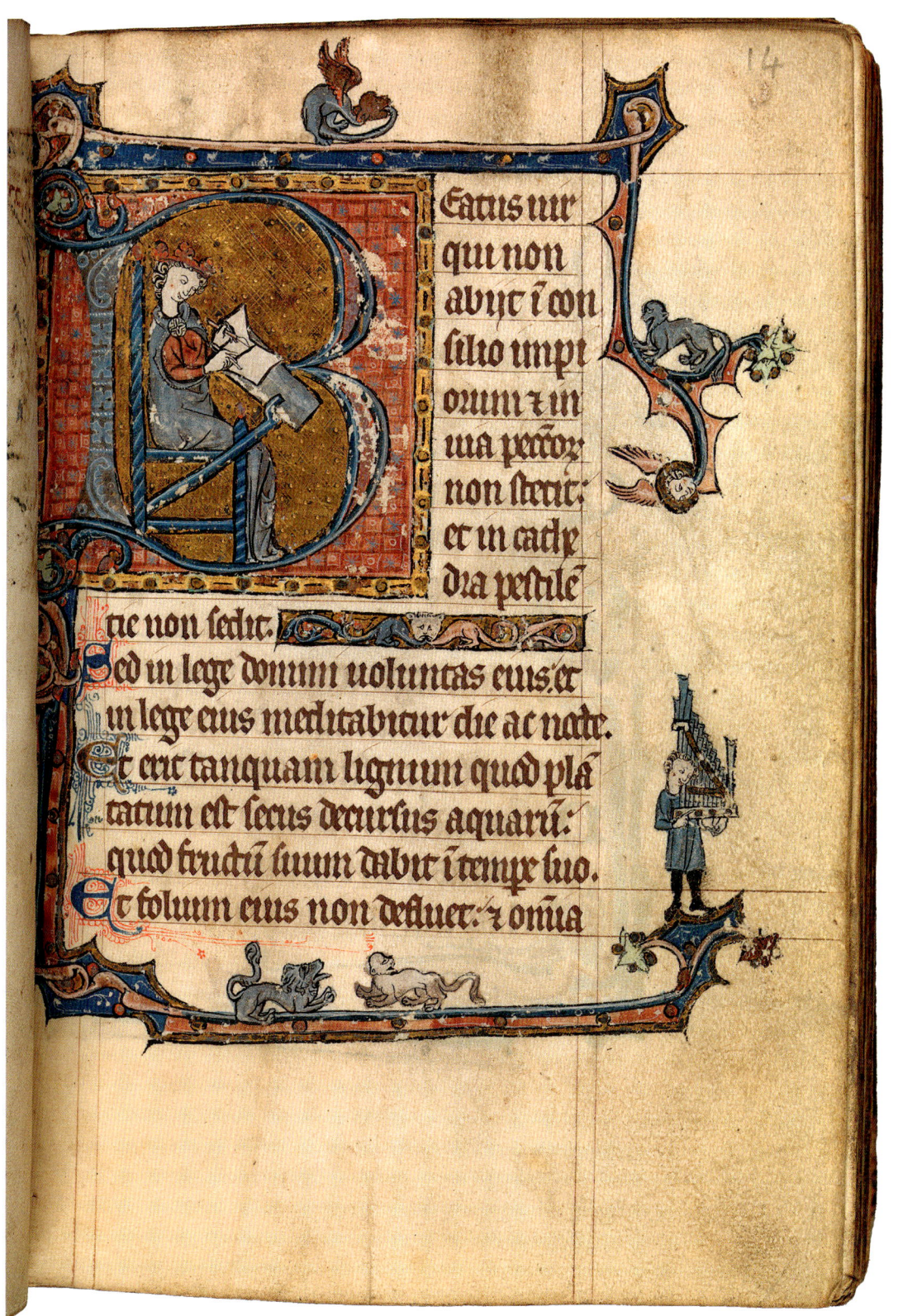

Beatus uir
qui non
abijt in con
silio impi
orum z in
uia precor
non stetit:
et in cathe
dra pestile
tie non sedit.
Sed in lege domini uoluntas eius. et
in lege eius meditabitur die ac nocte.
Et erit tanquam lignum quod pla
tatum est secus decursus aquarum:
quod fructum suum dabit in tempe suo.
Et folium eius non defluet: z omnia

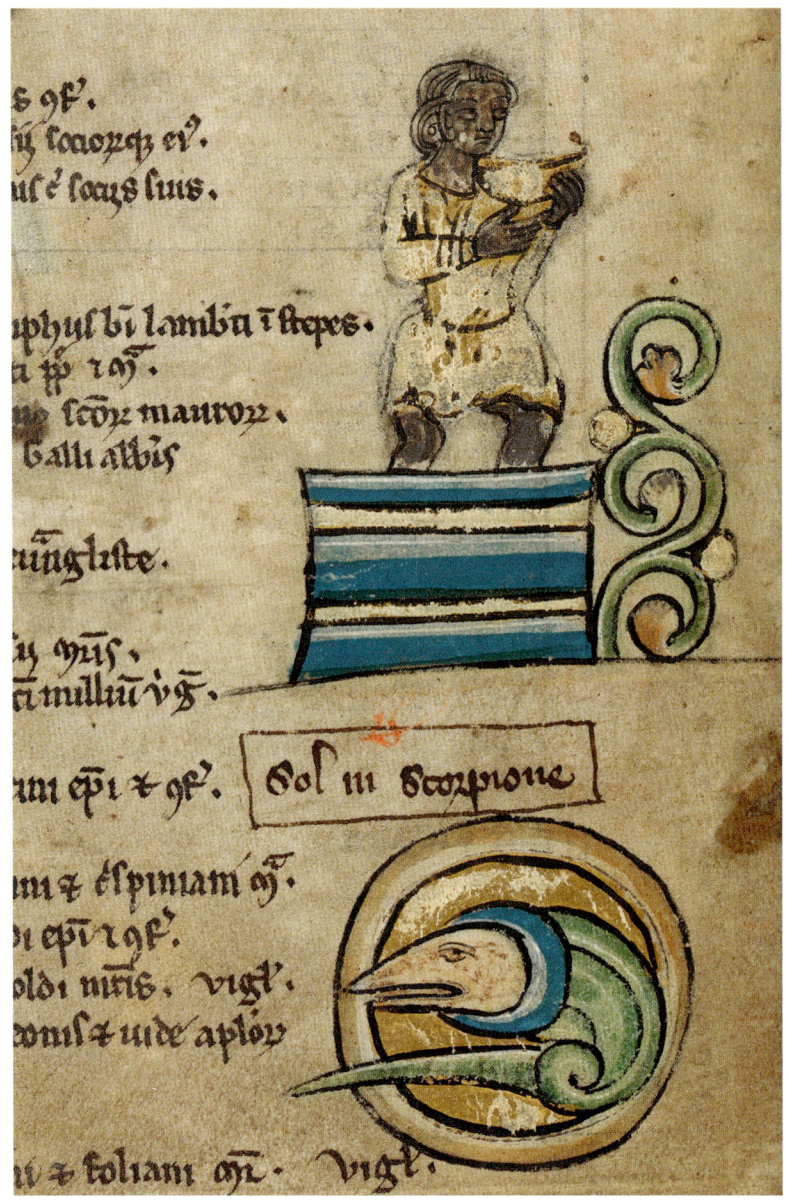

8 Trinity College Library MS 90 f. 3v, detail. © The Board of Trinity College Dublin.

of calendars usually also introduced imagery associated with more earthly concerns. Much of the imagery included in calendars, logically, explored the passing of time through references to the cycle of the zodiac, and the changing seasons. Thus each month became associated with a sign of the

34

Tertii octob's gladi' in x ordine nectit.
Octob ht d xxxi l xxx.
Remigii epi co.

xvi	a			
v	b	vi		Leodegarii m.
	c	v	n	duor ewaldoy
xiii	d	iiii	o	francisci co.
ii	e	iii		
	f	ii		
x	g	nona	s	Marci pp.
	a	viii	l	amoris co.
xviii	b	vii	d	ysonisii mr
vii	c	vi	v	Geronis m.
	d	v	s	
xv	e	iiii	d	
iiii	f	iii	d	tsph[?] lamber
	g	ii	v	calixti pp tm
xii	a	idv's	s	
i	b	xvii	k	Galli abbtis.
	c	xvi	a	
ix	d	xv	l	Luce euuagliste
	e	xiiii	c	
xvii	f	xiii	n	Caprasii in
vi	g	xii	d	xi milii v.
	a	xi	a	
xiiii	b	x	s	Severini epi co.
iii	c	ix	k	
	d	viii	a	Crispini mr
xi	e	vii	l	amandi co
	f	vi	c	vigilia
xix	g	v	n	Symonis z iude
viii	a	iiii	d	Narcissi mr
	b	iii	a	
xvi	c	ii	s	vigilia.

9 Oxford, Bodleian Library MS Add. A. 46 f. 5v. © The Bodleian Libraries, The University of Oxford.

zodiac and a particular activity or labour of that month. The calendar pages in Chester Beatty Library MS W. 61 leave out the zodiac symbols to maximize space for the large images of the labours of the months, which include aristocratic activities such as hawking in May. In Trinity College Library MS 90, however, the surviving images of labour are focused on agricultural activities and climatic conditions, including a man keeping warm by the fire in January and a man pressing grapes in October (Fig. 8). The grape-presser stands in a vat with his tunic hitched up to allow him to crush the grapes with his bare feet. Next to the vat swirling foliage suggests the vines from which the grapes have been harvested, and the figure lifts a bowl to his mouth to indicate the form of the finished product. The images of the labours are set above the relevant signs of the zodiac, for example the symbol for Scorpio in October. In Trinity College Library MS 90 Scorpio looks rather like a snake with a long body and twisted tail. The symbol is more commonly represented as a scorpion-like creature with legs, as in Oxford, Bodleian Library MS Add. A. 46, which perhaps indicates the form from which the creature in the Dublin manuscript was derived, and which also features a more detailed representation of wine production (Fig. 9).

 Not all the decoration in Psalters had a clear Christian message or was obviously linked to the text. In margins and line-fillers in particular artists sometimes had the opportunity to display their skills in playful or even satirical imagery. In Chester Beatty Library MS W. 61 the major divisions of the Psalter have borders that are filled with grotesque creatures, together with men and animals behaving strangely. These include a creature with the body and wings of a dragon, but the head of a tonsured monk or cleric on folio 61. Moreover, on the tail of this beast sits a rabbit reading a book, which is being attacked by a fox (Fig. 10). While this might be interpreted by the devout as a warning about the dangers of being caught by sin, as the fox was presented in the medieval bestiary as a deceitful creature, it was also probably intended to entertain. Other creatures in the margins of this manuscript include a cat, a monkey, and a man balancing a column on his face, on top of which is a squirrel. In a similar vein, the margins and line-fillers in Trinity College Library MS 91 include grotesques such as a dragon-like creature that bites its own tail, and a beast with one head and two bodies. Trinity College Library MS 92 contains what seems to be overtly satirical imagery in some of its margins,

10 Chester Beatty Library MS W. 61 f. 61, detail. © The Trustees of the Chester Beatty Library, Dublin.

including a bird with the head of a bishop on folio 26v, and the torso of a richly dressed man, with a pair of bellows on his head on folio 22v (Fig. 11). The bellows also resemble a mitre, and this image may once again be intended to poke fun at the church hierarchy; taken together with the man's open mouth it suggests verbosity on the part of this individual, and an alternative form of noise to the music and prayers of the Psalms. In this context the imagery may have been inspired by the last verse of the Psalm adjacent to the image, 'the words of my mouth shall be such as may please: and the meditation of my heart always in thy sight. O Lord, my helper, and my redeemer'.

The diverse Psalters preserved in the collections of Trinity College and the Chester Beatty Library are a reminder that every medieval Psalter was unique. The choices made by patrons and artists concerning decoration were one of the ways in which the appearance and function of these books was shaped. The addition of figurative imagery, in particular, could inform the ways in which the Psalms were read, emphasizing aspects such as the importance of David and his story in their composition and interpretation or the potential to read the Psalms in the light of Christ's story. Decoration could also help a user locate particular points in the text in order to follow the liturgy. Some Psalters were used regularly and carefully, others may have been used until they fell to pieces and are thus

11 Trinity College Library MS 92 f. 22v, detail. © The Board of Trinity College Dublin.

now lost to us, and some may have been read only rarely. In addition to being devotional tools, Psalters could also be displayed as luxury objects indicating an owner's wealth and status. The illumination of the Psalter thus sheds light on medieval attitudes to the Psalms, the creativity of artists and the ambitions of patrons.

FURTHER READING

J.J.G. Alexander, *Medieval Illuminators and Their Methods of Work* (New Haven & London, 1992).
P. Binksi & S. Panayotova (eds), *The Cambridge Illuminations: Ten Centuries of Book Production in the Medieval West* (Cambridge, 2005).
M. Brown, *Understanding Illuminated Manuscripts: A Guide to Technical Terms* (London, 1994).
B. Cassidy & R.M. Wright, *Studies in the Illustration of the Psalter* (Stamford, 2000).
R. Gameson, 'The Cost of the Codex Amiatinus', *Notes and Queries*, 237 (1992), pp 2–9.
C. de Hamel, *Scribes and Illuminators* (London, 1992).
V. Sekules, *Medieval Art* (Oxford, 2001).

The Library Collections: Patronage and Provenance

Laura Cleaver

The Psalters now held by Trinity College and the Chester Beatty Library were produced in the regions of modern Britain, France, Belgium, Germany and Italy, and most changed hands many times before their arrival in Dublin. Some volumes were designed for use in monasteries, others for wealthy individuals, and their current places in the Dublin collections, where they are consulted by scholars and displayed to the general public, bears little resemblance to the circumstances in and for which they were made. Many of the Psalters contain information not only about their makers and original users, but also about subsequent owners and readers. In addition, sources such as library lists and sale catalogues can provide information about the history, or provenance, of these volumes. Trinity College Library owes the core of its manuscript collection to James Ussher, Archbishop of Armagh and Primate of All-Ireland. The Chester Beatty Library is even more the creation of one man: Sir Alfred Chester Beatty. In 1661 the collection of James Ussher, who had died in 1656, was given to Trinity College, the institution to which Ussher had once hoped to donate it, providing a significant contribution to the growing library's manuscript holdings. Sir Alfred Chester Beatty's collection still bears his name, having been given in trust to Ireland, together with the resources to exhibit it, at his death in 1968. The acquisition (as well as the sale, exchange and donation) of manuscripts by these two men played a substantial part in the development of the two collections, but both libraries also owe debts to others, as both Ussher and Chester Beatty benefitted from a thriving trade in medieval manuscripts in their lifetimes, and both collections have expanded through subsequent purchases and gifts.

Five of the Psalters now held in Trinity College Library's collection can be traced to the collection of Archbishop Ussher, as manuscripts 53, 69, 91, 93 and 600 are all inscribed with the shelf-marks he used in his own library. In addition, the oldest Psalter now in the collection, the Ricemarch

Psalter (Trinity College Library MS 50), was probably part of Ussher's collection. The history of this manuscript can be traced to an earlier figure associated with the College, as it was previously owned by William Bedell, Provost of Trinity College from 1627 to 1629, whose name appears on folio 2. Bedell left the manuscript to Ussher in his will 'in testimony of my true and hearty affection to him'.[1] Bedell's will also left manuscripts to the libraries of Emmanuel College Cambridge, and Trinity College Dublin. The latter was to receive 'my manuscript Priscian with four more of my manuscripts, such as my executor shall think fit'. Following the Reformation in the sixteenth century, large numbers of manuscripts previously preserved in church libraries had passed into private hands, stimulating an interest in old books among scholars and a significant trade in manuscripts. Bedell had lent the Ricemarch Psalter to Ussher in the 1620s, and Ussher was part of a network of scholars who borrowed each other's books in pursuit of their interests, usually (though not always) managing to return them. A collection of Ussher's notes now in the Bodleian Library in Oxford (MS Rawl. D. 1290) contains a list of books lent to others, including references to Psalters lent to his brother Ambrose (Fig. 12). The volume also contains notes for Ussher's sermons, some of which focused on particular Psalms. Ussher was primarily interested in the text of the Psalms, and Bedell recorded of the Ricemarch Psalter that Ussher 'told me he did esteem it even for the translation's sake (being not Vulgar, but according to ye Hebrew Verity)'.[2]

In addition to Archbishop Ussher's books, other Latin Psalters in Trinity College Library contain traces of their seventeenth-century owners. Trinity College Library MS 90, a thirteenth-century Psalter, has a note on folio 2 identifying it as the gift of Thomas Hally and as being in the College in 1672. Hally is perhaps related to the Thomas Halley who received an MA degree from the College in 1673, but the names of Thomas and William Hally also appear in one of Ussher's notebooks (Trinity College Library MS 790). The fifteenth-century Psalter made in England for the Wingfield family (Trinity College Library MS 93) was described in the College catalogue of *c.*1670 (Trinity College Library MS 7/2) as 'a very fair' Psalter, and had thus arrived at the College by that date. In

[1] London, National Archives Prob/11/240. [2] T.W. Jones, *A True Relation of the Life and Death of the Right Reverend Father in God William Bedell* (London, 1872), p. 257.

12 Oxford, Bodleian Library MS Rawl. D. 1290 f. 1. © The Bodleian Libraries, The University of Oxford.

[This manuscript page is heavily damaged, faded, and difficult to read. Partial transcription follows.]

Scoti de rebus Hibernicis
... graece lexicon

Dict. Pantomethia
Norden Speede Britannia

Singularia Juris
Book of ?... ...Willet upon Gen. 17
Scribonij ...
Scribonij Ethica
Dispensaria medica 5. 49. 6. 2.
Brestii Hygieina 20. 18
Dasypodius

Downam de Antichristo 6. 43. 20.
Ussher / Bilstenij Syntag. 11
D. Andrews serm. of ye Passion 6. 9. 20.
Webbe / Grants Greek Grammer
Reynold against Hart
Bourchier / Lipsii Electro...
Gentilis de leg. ...

Calvin ... Hebr. ...
Lindens Grammer ...
Campensis in Psalmos ...
De...ius transl. nov. Test.
Postelli Arabica Grammatica
Brinston contra ...
... Casaubon ad Peron...

James Simple / Cartwright agst ye ...
M^r Hill / Brinsley upon Job
Finch of Ceremonies

M^rs Hill / ...mysterie of selfe deceiving
Some ... his colours. Cartwright de Witgift.

M^rs Temple / Stocks sermon of L. Haringtons death
M^rs Crook / Besa...
H. Wotton epistoli
Mercury Gallobelgicus an. 1618
Cock / Zacchius de rebus ...
Molton in Psalms
Whitaker

addition to the Windfield coat of arms, the names of later owners or readers include one John Stanley, whose name appears with the date 1611 (f. 1), and Thomas and George Ravenscroft[e], the former of whom is described on folio 95 as a 'lover of study'. These men were probably members of the Ravenscroft family based in Flintshire, who were distantly related to the Wingfields. The Thomas Ravenscroft referred to may also be the man who published a collection of musical settings for Psalms under the title *The Whole Booke of Psalmes with the Hymnes Evangelicall and Songs Spirituall* in 1621. In addition, two women's names appear in the manuscript as the Ravenscroftes' names are joined on folio 94 by the name Anne Siddney, and medical treatments, some of which are attributed to Mary St Leger, are inscribed on the flyleaves together with the date 1574. The inclusion of the remedies indicates the close connection between prayer and attempts at medical treatment both in the Middle Ages and subsequently. In a thirteenth-century Psalter from Augsburg, Chester Beatty Library MS W. 40, German notes indicate the usage of each Psalm, and some are identified as Psalms to be said for the sick and dying. Similarly the additions to Trinity College Library MS 92, a late fourteenth-century Psalter also from England, include a prayer to Saint Sebastian against plague. This manuscript also appears in the catalogue of manuscripts at Trinity College compiled in the 1670s, but presumably earlier in the seventeenth century one George Smalley wrote his name on folio 100 to identify it as his possession. Smalley also added the suitably pious comment 'think and thank, refrain and sustain'.

The content and decoration of Trinity College Library MS 92 may also provide clues to its owners before it came into the hands of George Smalley. Unfortunately the opening pages of the volume, where references to owners were most commonly found, are now lost. Yet a leaf from a Missal printed in 1508 containing an image of King Henry VII and his wife Elizabeth of York kneeling before images of the crucifixion set into the monogram of Christ's name (IHS) has been added to the end of the Psalter (Fig. 13). The image has been painted, with the roses coloured red, emphasizing Henry's Lancastrian heritage. Although this leaf is a later addition to the book, and may have been included as a tool for meditation on the crucifixion, the imagery resonates with the initials in the Psalter, which include a red rose on folio 89v, at the start of Psalm 146 ('praise ye the Lord, because [the] psalm is good: to our God be joyful and comely

13 Trinity College Library MS 92, added folio from *Missale secundum usum insignis ecclesie Sarum*, published by A. Verard (Paris, 1508). © The Board of Trinity College Dublin.

praise'), and a scene on folio 12 (at the Hour of Terce) in which a man offers red flowers to a female saint, probably, given the position of the initial in the Hours of the Virgin, the Virgin herself. The Virgin holds a scroll which asks '*Que signifie cele fleur*' ('what is the significance of this flower'). Unfortunately most of the answer that was probably contained on the man's scroll is now lost. The rose was often associated with the Virgin, but in the late fourteenth century, when this manuscript was made, it was also an emblem used by the house of Lancaster, and it is possible that both associations may have been intended here. An interest in royalty is further suggested by the initial on folio 69v which, in addition to the commonly used image of the clergy singing the Psalms at Psalm 97 'Sing to the Lord a new song' (*Cantate Domino canticum novum*), includes a figure of a king who closely resembles the figure of God above, providing a play on temporal and spiritual lordship (see Figs. 5–6). This figure may represent David, the reputed author of the Psalms, but as he is shown in medieval dress the distinction between biblical and contemporary monarchy is blurred. A manuscript with very similar imagery now in Edinburgh (National Library of Scotland MS 18.6.5) was made for Eleanor de Bohun, wife of Thomas, Duke of Gloucester, youngest son of Edward III. Among Thomas' brothers was John of Gaunt, Duke of Lancaster. It seems possible, therefore, that this book was made for someone with connections to the royal family. Henry IV, who became king in 1399, was the son of John of Gaunt and Blanche, Duke and Duchess of Lancaster, and John of Gaunt had acted as regent during the minority of the previous king, his nephew Richard II.

Other Psalters in Trinity College Library's collection provide stronger evidence for early owners or users. This is a relatively common occurrence in Psalters, which were often made as personal or family prayer books. An exception is the large twelfth-century Winchcombe Psalter (Trinity College Library MS 53), which, on stylistic grounds, was probably made for the monastic community at Winchcombe, Gloucestershire. The manuscript has a much later note on its flyleaves recording that the book was given to the library at Winchcombe by Richard of Kidderminster, who was abbot of the community from 1488 to 1525. However, this does not necessarily mean that the book was not already at Winchcombe, as Richard may have discovered it during his researches into the abbey's history and then given it to the monastic library. In contrast most of the Psalters in

the Trinity College and Chester Beatty Library collections can be associated with individuals or families. The Ricemarch Psalter (Trinity College Library MS 50) contains a text on folio 158v claiming that it was made for Ricemarch (bishop of St David's 1088–1096) by Ricemarch's brothers – Ithael the scribe and John the illuminator. Similarly, in the fourteenth century John Hyde's name was included in a Psalter with an English translation (Trinity College Library MS 69), suggesting that the volume was to be associated with him, and in the sixteenth century Johannes Mülech wrote his name on the inside cover of Trinity College Library MS 11042.

In addition to the names of owners, the material added to Psalters can suggest a place of origin for some manuscripts. In the calendar of the thirteenth-century Chester Beatty Library MS W. 40 the names of saints Ulric and Afra are written in capital letters, suggesting that they were considered particularly significant. Both saints' cults were centred on Augsburg, and the inclusion of other saints associated with that region suggests that the manuscript was made for someone with connections to that city. The calendar also includes a reference to the dedication of a church on the 28th September, which refers to the dedication of Augsburg cathedral in 1065. The manuscript was certainly in Augsburg in the sixteenth century as a note pasted into the volume declares that in 1595 Master Leonhard Seyler, vicar and member of the cathedral chapter of Augsburg, gave the volume to the convent in which his sister had lived, together with a statue of Saint Narcissus (who was responsible for Afra's conversion to Christianity) containing relics of that saint and Saint Peter, a silver cross housing a piece of the True Cross, and a painted cloth showing Leonhard kneeling before a scene of the crucifixion. Leonhard thus hoped to be remembered eternally in the prayers of these nuns.

The original ownership of Trinity College Library MS 93 is proclaimed by a coat of arms in the lower margin of the full-page image with which the Psalter opens (f. 1v). The arms identify the patrons of the work as Sir John Wingfield (whose arms including three pairs of 'wings' are on the left) and his wife Elizabeth Fitzlewis, and the manuscript may have been made to commemorate their marriage in c.1450 (Fig. 14). The Wingfields lived at Letheringham in Suffolk, and Sir John held a series of important offices, including serving as a privy councillor to Edward IV. The marriage produced at least sixteen children, and the whole family,

together with John's father and brother, were commemorated in a painting that now survives in two versions, one now in the Buccleuch Collection, and the other formerly at Tickencote Hall (Fig. 15). At the heart of the painting John and Elizabeth kneel in prayer. Their arms are set above them, but also appear in their dress. Both figures have books open before them, underlining the importance of volumes such as their Psalter for devotion, as well as serving as status symbols, like the painting itself. A fifteenth-century Italian Psalter, Trinity College MS 106, also contains a coat of arms, which is as yet unidentified (Fig. 16). However, in the sixteenth century Francesco di Gobbi added his name on folios 5v and 37v. The first of these entries is next to the calendar entry for Saint Francis, his name-saint, while the second is written under Psalm 34:27 'let them rejoice and be glad' – once again suggesting that the manuscript's owner closely identified with the text.

In the twentieth century, as some families sold off their libraries, Sir Alfred Chester Beatty made great use of the growing trade in early books to build an exceptional collection of manuscripts, acquiring his books both at auctions and through private transactions. R.J. Hayes, Honorary Librarian of the collection, observed that 'Sir Chester Beatty became known to every rare book dealer in London, Paris and New York as a generous buyer who insisted on fine quality and was prepared to pay high prices to obtain it'.[3] In the course of his collecting Chester Beatty acquired parts of at least six Latin Psalters; however, only two remain in the collection, the others having been sold at auctions in the 1930s and 1960s. The volumes he parted with included a twelfth-century glossed Psalter now in Stuttgart (Landesbibliothek MS Theo. & Phil. Fol. 341) and six leaves with full-page images by the thirteenth-century English artist William de Brailes, now in the Fitzwilliam Museum, Cambridge. Chester Beatty moved to Dublin in 1950 and opened his collection to the public from 1954. In 1955 manuscripts from Chester Beatty's collection were displayed in an exhibition in the Library at Trinity College, alongside manuscripts from the College's collection. In 2000 the new Chester Beatty Library, in the grounds of Dublin Castle, opened to the public, with extensive galleries in which much of the collection can be displayed.

3 *The Chester Beatty Western Manuscripts: Part One*, Sotheby's Sale Catalogue, 3.12.1968, p. 9.

14 Trinity College Library MS 93 f. 1v (detail). © The Board of Trinity College Dublin.

15 The Wingfield Family, Buccleuch Collection. By kind permission of the Duke of Buccleuch & Queensberry KBE.

The two Psalters that remain in the Chester Beatty collection were both purchased in the 1920s. MS W. 40 was purchased from the well-known London-based book dealers Bernard Quaritch Ltd, while MS W. 61 was acquired from R.G.L. Barrett in 1924. MS W. 61 had previously passed through the hands of another London book dealer, Maggs Bros., who included it in their catalogues in 1920 and 1921, claiming that 'we know of no manuscript with such a fine suite of calendar miniatures'. In 1921 Maggs Bros. put a price of £4,750 on the manuscript (roughly equivalent to €190,000 today).

The manuscripts of Trinity College and the Chester Beatty libraries are resources beyond value for twenty-first-century scholars and visitors to exhibition displays. Together with Psalters in collections around the world, they represent the surviving evidence for the use of this text in the Middle Ages and the subsequent treatment of such manuscripts through significant religious change and the rise and fall of the fortunes of institutions and families. The Psalter was one of the most popular devotional texts, and survives in thousands of manuscripts, yet each volume is unique and provides evidence not only for the circumstances of its production, but also its later history. The two Dublin collections considered here were largely created by two men with very different interests and attitudes to collecting. Yet both collections now enable visitors to engage with the richness of medieval belief and manuscript production.

FURTHER READING

T.C. Barnard, 'The Purchase of Archbishop Ussher's Library in 1657', *Long Room*, 4 (1971), pp 9–14.

E. Boran, 'The Libraries of Luke Challoner and James Ussher, 1595–1608' in H. Robinson-Hammerstein (ed.), *European Universities in the Age of Reformation and Counter Reformation* (Dublin, 1998), pp 75–115.

E. Boran, 'An Early Friendship Network of James Ussher, Archbishop of Armagh, 1626–1656' in H. Robinson-Hammerstein (ed.), *European Universities in the Age of Reformation and Counter Reformation* (Dublin, 1998), pp 116–34.

R.O. Dougan, *Western Illuminated Manuscripts from the Library of Sir Chester Beatty Exhibited in the Library of Trinity College, Dublin* (Dublin, 1955).

E. Duffy, *Marking the Hours: English People and Their Prayers, 1240–1570* (New Haven & London, 2011).

R.J. Hayes, 'Sir A. Chester Beatty and His Library', *The Princeton University Library Chronicle*, 28 (1967), pp 141–9.

T.W. Jones, *A True Relation of the Life and Death of the Right Reverend Father in God William Bedell* (London, 1872).

D. McKitterick, 'The Eadwine Psalter Rediscovered' in M.T. Gibson, T.A. Heslop & R.W. Pfaff (eds), *The Eadwine Psalter: Text, Image, and Monastic Culture in Twelfth-Century Canterbury* (University Park, 1992), pp 195–208.

E.G. Millar, *The Library of A. Chester Beatty: A Descriptive Catalogue of the Western Manuscripts*, 2 vols (Oxford, 1927).

W. O'Sullivan, 'Introduction to the Collections' in M.L. Colker, *Trinity College Library Dublin: Descriptive Catalogue of the Mediaeval and Renaissance Latin Manuscripts* 1 (Aldershot, 1991), pp 21–46.

Maggs Bros., *Illuminated Manuscripts and Miniatures,* No. 404 (London, 1921).

Catalogue of the Renowned Collection of Western Manuscripts the Property of A. Chester Beatty Esq.: The First Portion, Sotheby's Sale Catalogue 7.6.1932.

Catalogue of the Renowned Collection of Western Manuscripts the Property of A. Chester Beatty Esq.: The Second Portion, Sotheby's Sale Catalogue 9.5.1933.

The Chester Beatty Western Manuscripts: Part One, Sotheby's Sale Catalogue, 3.12.1968.

The Chester Beatty Western Manuscripts: Part Two, Sotheby's Sale Catalogue, 24.6.1969.

See also bibliography for particular manuscripts given in the catalogue below.

16 Trinity College Library MS 106 f. 7 (detail). © The Board of Trinity College Dublin.

The Catalogue

Trinity College Library MS 50, The Ricemarch Psalter

Martyrology and Psalter (Hebraicum)
160 x 105 mm, 159 folios
*c.*1079, Llanbadarn Fawr, Wales

This very small volume has been carefully organized and executed. The original owner's identity is revealed by verses at the end of the manuscript, which identify him as Ricemarch, son of Sulien, and both father and son held the office of bishop of Saint David's. The same text identifies Ricemarch's brothers John and Ithael as having decorated and written the manuscript respectively. The script is a finely realized Welsh version of Insular miniscule. Each Psalm begins with an initial comprised of interlace, and many of these feature animal heads. The Psalter is divided into three parts at Psalms 1 (f. 35), 51 (f. 70) and 101 (f. 118), and these divisions are marked by decorated pages, with larger script and borders featuring animal heads and feet, filled with interlaced creatures. At the major divisions the area behind the text is painted yellow and the spaces between the lines are painted green. The use of interlace and red dots around the opening letter looks back to a tradition of Insular book decoration that flourished from the eighth century.

On folio 35 the Psalms begin with the letter B for 'Beatus' made up of a quadruped with elaborately intertwined limbs. The creature of the letter B seems to be menaced by the creature-border that surrounds the rest of the first verse of the Psalm as its head faces away from the border. The beast that forms the border, which may be a cat, has presumably already consumed the twisted creatures within it. The text of Psalm 1:1 is written out in full and declares 'Blessed is the man who hath not walked in the counsel of the ungodly, nor stood in the way of sinners, nor sat in the chair of derision' (*Beatus vir qui non abiit in consilio impiorum, et in via peccatorum non stetit, et in cathedra derisorum non sedit*).

BIBLIOGRAPHY

Lawlor; Alexander (1978); Colker (1991); Henry and Marsh-Micheli; Edwards.

17 Trinity College Library MS 50 f. 35, Psalm 1:1. © The Board of Trinity College Dublin.

Trinity College Library MS 53, The Winchcombe Psalter

New Testament, and Psalter in the Gallican and Hebraicum versions
430 x 290 mm, 192 folios
*c.*1130–40, Winchcombe, England

This large manuscript was probably made at and for Winchcombe Abbey in England. The text, written in an expert proto-gothic hand, is clear and set out in two carefully ruled columns with the Gallican text on the left and the Hebraicum text on the right. The numbering follows the Gallican version. There are, however, some errors in the text, apparently caused by the challenge of copying two versions of the Psalms side by side. For example, the person charged with executing the coloured text for the first verse of Psalm 1 has written the same text twice, repeating the Gallican reading *pestelentiae* rather than the Hebraicum *derisorum*. Similarly, the end of verse 5 in the Hebraicum version has been inserted above verse 4, suggesting either a lack of attentiveness to the text or to the spatial layout. The three major divisions of the Psalter are marked by large foliate initials (see Fig. 1). In addition, the start of Psalm 109, the first Psalm of Sunday Vespers, is indicated by initials that are larger than those at the start of most Psalms, though smaller than those of the major divisions. The Psalter is prefaced by a gathering containing a collection of introductory material about the Psalms, suggesting that the manuscript was designed for study and underlining the importance of close reading indicated by the inclusion of the two translations of the Psalms.

Because the Psalter contains both the Gallican and Hebraicum versions of the text it opens with two Beatus initials and to distinguish between the different texts the artist has used different forms of the letter B. In the centre of the larger initial on the left, David sits with a harp. In the other roundels musicians play horns, bells, and a viol, while a man dances. The rest of the initial is composed of a swirling vine scroll populated by creatures including lions, a horse, and several grotesque hybrid creatures. In the other initial, which may be unfinished, David appears again, this time dancing before the Ark of the Covenant. David

18 Trinity College Library MS 53 f. 151, Psalms 1:1–2:9. © The Board of Trinity College Dublin.

EATUS VIR
QUI N̄ ABIIT
IN CONSI
LIO IMPIOR
ET IN VIA
PECCATORŪ
N̄ STETIT ET IN
CATHEDRA PES
TILENTIE NON
SEDIT

EATUS
VIR QUI NON
ABIIT IN CONSILIO IMPI
ORŪ ET IN VIA PECCATOR
NON STETIT ET IN CATHE
DRA PESTILENTIE N̄ SEDIT

Sed in lege dñi uoluntas eius: & in lege eius meditabit͂
die ac nocte. tempore suo.
Et erit tanquam lignum quod plantatum est secus
decursus aquarum: quod fructum suum dabit in
Et folium eius non defluet. & oīa quecūque faciet
prosperabuntur. In consilio iustorum.
Non sic impii ÷ non sic: sed tanquam puluis quem
proicit uentus a facie terrę:
Ideo non resurgunt impii in iudicio: neque peccatores
Qm̄ nouit dñs uiam iustorum: & iter impiorum
peribit. II. PSALMUS DAVID.
Quare fremuerunt gentes: & populi meditati
sunt inania. Asterunt reges t'rę & principes conuenerunt in unum ad
Dirumpamus uincula eorum: & proiciamus ÷ a nob.
iugum ipsorum. nabit eos.
Qui habitat in cęlis irridebit ÷ eos: ÷ &: dñs subsan
Tunc loquetur ad eos in ira sua: & in furore suo con
turbabit eos. Saul predicans preceptum eius.
Ego autem constitutus sū rex ÷ ab eo: sup sion monte scm
Dñs dixit ad me filius ms es tu: ego hodie genui te.
Postula a me & dabo tibi gentes hereditatem tuam:
& possessionem tuam terminos terrę. Reget eos.
Reges eos in uirga ferrea: & tanquā uas figuli confrin

Sed in lege dñi uoluntas eius: & in lege eius meditabit͂
die ac nocte. tempore suo.
Et erit tanquam lignum transplantatum iuxta
riuulos aquarum. quod fructum suum dabit in
Eo folium eius non defluet. & omne quod fecerit
prosperabitur. In congregatione iustorum.
Non sic impii. sed tanquam puluis quem
proicit uentus.
Propterea n̄ resurgent impii in iudicio. neque peccatores
Qm̄ nouit dñs uiam iustorum: & iter impiorum
peribit. II.
Quare turbabunt gentes: & tribus meditabunt
inania. Asterunt dñm: & aduersus xpm eius.
Consurgent reges t'rę & principes tractabunt pariter ad
Dirumpamus uincula eorum: & proiciamus
laqueos eorum.
Habitator cęli ridebit. dñs subsannabit eos.
Tunc loquetur ad eos in ira sua: & in furore suo con
turbabit eos. Saul annuntiabo dei preceptum.
Ego autem ordinatus sū rex meus sup sion monte scm
Dñs dixit ad me filius ms es tu: ego hodie genui te.
Postula a me & dabo tibi gentes hereditatem tuam:
& possessionem tuam terminos terrę.
Pasces eos in uirga ferrea. ut uas figuli conteres eos.

bends over backwards with his hands almost touching his feet, while the Ark (which resembles images of medieval reliquaries) is placed at the top of the initial. From a roundel in the body of the letter Michal, David's wife, looks on, a detail based on 2 Samuel 6 and 1 Chronicles 15:29, in which she despises him for his actions, and is punished by becoming barren. A similar combination of imagery (although in a single initial and without Michal) is found in the Shaftesbury Psalter (British Library, Lansdowne MS 383 f. 15v) of around the same date. The imagery thus provides a context for the original composition of the text. In both cases the combination of sacred music and monstrous creatures, which in the Winchcombe Psalter may also serve as a parallel for Michal, may represent the contrast drawn between the blessed and the ungodly in Psalm 1.

BIBLIOGRAPHY

Colker (1991); Heimann (1965); Kauffmann (1978); see also Kauffmann (2003).

19 Detail from Trinity College Library MS 53 f. 151. © The Board of Trinity College Dublin.

57

Chester Beatty Library MS W. 40

Psalter (Gallican)
257 x 170 mm, 186 folios
1240–60, Augsburg, Germany

A slight emphasis placed on the names of Saints Ulrich and Afra, together with the inclusion of Saints Narcissus, Hilaria and Digna, all saints venerated in Augsburg, and a reference to the dedication of a church on the 28th of September, the day on which Augsburg cathedral was dedicated, in the manuscript's calendar, suggests that the volume was made in that city. The inclusion of Saint Elizabeth of Hungary in the calendar indicates that the volume post-dates her canonization in 1235. The text is written in a conservative Gothic book-hand. Most of the Psalms are accompanied by marginal quatrains in German directing the reader to say the text in particular circumstances, such as sickness, imprisonment, travel, and when approaching the sacrament. In addition to the calendar, which includes zodiac symbols, the Psalter contains large initials with gold backgrounds at Psalms 1 (f. 7), 26 (f. 32v), 38 (f. 48v), 51 (f. 63), 52 (f. 64), 68 (f. 79), 80 (f. 97), 97 (f. 113v), 101 (f. 116), and 109 (f. 131), dividing the Psalter into ten sections. Psalms 1, 26, 38, 52, 68, 80, and 97 were the first Psalms sung at Matins during the week, Psalms 1, 51, and 101 represented the three-part division of the Psalter, and Psalm 109 was the first Psalm at Vespers on Sundays. In this volume the divisions are also marked by leather tabs, allowing the user to open the volume immediately at these texts (see Fig. 3). Some of the images retain their protective curtains – pieces of silk sewn into the manuscript to protect areas of decoration. Five of the initials contain human figures, and the remains of a gathering that has been cut away between the calendar and the start of the text may suggest that the book once had a series of prefatory miniatures. In the Beatus initial for Psalm 1 David plays a lyre. At the start of Psalm 26 Saint Nicholas stands holding a book and crozier, while at Psalm 38 Saint Francis stands in the letter D, displaying his wounds. Saint Michael slaying a grotesque creature that appears to be part dragon and part demon is the subject of the initial to Psalm 51, as the text asks 'Why doest thou glory in

nique. Quid retribuam mal-
bonis detrahebant michi quo-
ba. boutate. Non derelinqu
dne ds ms ne discesseris a
tende in adiutoriu meu dne
salutis mee:

den spricht so du
ter gotes lichā
nemest · vñ spricht
da buch vū mem
engel

C VSTODIAM VIAS MEAS:
meas ut nō delinquā in lingua

mea. Posui ori meo custodiā: cū con
sisteret peccator aduersum me. Ob
mutui et humiliatus sum & silui
a bonis: & dolor meus renouatus ē:
Concaluit cor meū intra me: & in me
ditatione mea exardescet ignis.
Locutus sum in lingua mea: notum
fac m dñe finē meū. Et nume
rum dieru meoꝝ quis est ut sciam
quid desit m. Ecce mensurabiles
posuisti dies meos: & substantia mea
tamquā nichilū ant te. Verūta
men uniuersa uanitas: omnis homo
uiuens. Verūtam in imagine p
transit homo: sed et frustra contur
batur. Thesaurizat: et ignorat.
cui congregabit ea. Et nūc que

20 Chester Beatty Library MS W. 40 ff. 48v–49, Psalm 38:1–8.
© The Trustees of the Chester Beatty Library, Dublin.

59

Custodiam vias Meas

21 Detail from Chester Beatty Library MS W. 40 f. 48v.
© The Trustees of the Chester Beatty Library, Dublin.

malice, thou that art mighty in iniquity?' (*Quid gloriaris in malicia, qui potens es in iniquitate*). Finally, Adam and Eve are shown eating the forbidden fruit on folio 116 at the start of Psalm 101.

The start of Psalm 38, 'I said: I will take heed to my ways, that I sin not with my tongue' (*Dixi custodiam vias meas meas ut non delinquam in lingua mea*), contains an image of Saint Francis of Assisi displaying the wounds on his hands, feet and side received during a vision. Francis died in 1226, and was canonized in 1228. The order he founded proved hugely popular in the thirteenth century, and spread rapidly across Europe. Augsburg was an important centre for the Franciscans, with the first friars arriving there in 1221. In the initial Francis presents his wounds, which echo Christ's, to the viewer. The marginal text instructs the reader to 'say this when you take the body of God [i.e., the Eucharist], and also for your angel', resonating with Francis' devotion to the Eucharist.

BIBLIOGRAPHY

Millar Vol. 1; Swarzenski; Dougan; Worm.

Trinity College Library MS 90

Psalter-Hours
192 x 130 mm, 178 folios
*c.*1255–65, Liège, Belgium

This Psalter is now in poor condition, probably as the result of significant usage, but it was once a relatively elaborate devotional manuscript of a type produced in large numbers in the Mosan region. The text is neatly executed in a fully developed Gothic script, and the Psalter text is prefaced by a calendar. On folio 93 part of Psalm 118 was copied twice, but the repeated section has been crossed through. The manuscript is now missing its Beatus page, together with the folios that would have contained the calendar for the months of May to August. On the surviving calendar pages each month is decorated with an image of the relevant zodiac symbol and labour of the month. The feasts listed in the calendar suggest that the manuscript was made in the area of Liège. These include five feasts for Saint Lambert, whose relics were kept at Liège, and the feast day of Saint Hubert, the first bishop of Liège, on the third of November. Most of the Psalms begin with neatly executed initials in red and blue penwork, but ten Psalms have been marked out as liturgical divisions with major initials containing gilded scroll patterns: these are Psalms 2 (f. 5), 26 (f. 21v), 38 (f. 32), 51 (f. 41v), 52 (f. 42), 68 (f. 52), 80 (f. 64), 95 (f. 75v), 101 (f. 77), and 109 (f. 87). Initials in the same style mark the start of the Canticles on folio 111, the Hours of the Virgin on folio 121, the Office of the Dead on folio 152v and the *Ave Porta Paradisi*, a poem in honour of the Virgin that draws heavily on the Psalms, on folio 171. Holes suggest that some of the gilded initials were once protected by curtains, but despite this provision, much of the gold has flaked off. The likelihood that this volume received considerable usage is also suggested by later annotations in the margins, including some sketches of boats.

 The opening shown here contains the calendar pages for the months of October and November. The dates are indicated on the left, together with letters to enable the reader to identify the days of the week. The majority of the text records the saints' feasts celebrated during these

22 Trinity College Library MS 90 f. 4, detail. © The Board of Trinity College Dublin.

23 London, British Library, Additional MS 21114 f. 6, detail. © The British Library Board.

24 *(overleaf)* Trinity College Library MS 90 ff. 3v–4, calendar for October and November. © The Board of Trinity College Dublin.

October

Terri... cobr gladius decimo ordine nectit.
KL

			Remigii germani ep̄i.
	b		Leodegarii ep̄i.
vii	c	iii	Duor̄ ewaldroum̄ cep̄.
	d	ii	
	e	nonas	Francisci ordis minor̄
	f	viii	
	g	vii	
viii	d	vi	Amoris ep̄.
vii	b	v	Dionisii sociorq̄; ev̄.
	c	iiii	Coronilē socius suus.
vi	d	iii	
iii	e	ii	
	f	idus	Triumphus b̄i lamb̄ti stepes.
xi	g	xix	Calixti pp̄ ros.
	a	xviii	Colom̄ s̄c̄ōr̄ mauron̄
	b	xvii	balli abb̄
ix	c	xvi	
	d	xv	Luce evangliste.
	e	xiiii	
xvii	f	xiii	Caprii m̄s.
	g	xii	Undecī milliū v̄g.
xiiii	a	xi	
	b	x	Severini ep̄i. et ēp. Sol in scorpione
	c	ix	
	d	viii	Crispini et crispiniani m̄.
	e	vii	Amadi ep̄i et ēp.
	f	vi	Rumoldi m̄tis. vigl̄.
vii	g	v	Symeonis et iude ap̄lor
	a	iiii	
xvi	b	iii	
	c	ii	Q̄tini et foliani m̄. vigl̄.

Louebris iiij ēra maior ī urna.
Nouemb̄. h̄. d. vrc. v. ręr

Sollempnitas oium sc̄or.
Comemoratio oium fidelium defunctor.
Hubti epī ēgf.

Leonardi ab̄b̄is.

Quatuor coronator mr̄tirum.
Theodori m̄rs.
Mirini p̄p ēgf.
Martini epī ēgf.
Cunibati epī ēgf.
Bricij epī ēgf.

Eugenij epī ēt ēius.

Oct sc̄i martini.
Gelasij p̄p ēgf.

Columbani ab̄b̄is.
Cecilie v.
Clementis p̄p ēt m̄r.
Grisogoni m̄rs.
Katerine v̄ḡ. īch.
Lini p̄p ēt m̄r.

Agricole ē uitalis.

vigil.
Andree ap̄li.

Sol in sagittario

25 London, British Library, Additional MS 21114 ff. 5v–6, calendar for October and November. © The British Library Board.

months. A later hand has added the feast of Saint Francis of Assisi, founder of the Franciscan order, on the fourth of October, while a different hand has recorded the changes in the zodiac cycle, which are noted in boxes. The zodiac is also the subject of the images in the roundels. On folio 3v the strange creature represents Scorpio, while on November's page a centaur with bow and arrow indicates Sagittarius. Both creatures break out of their roundels, and the flying arrow adds a sense of movement to the design, directing the viewer's attention towards the next page. The other images depict labours relevant to the months; in October a man in a wine-press treads grapes, holding a drinking vessel to make the purpose of his efforts clear. November is typically associated with fattening and killing pigs, and both activities may be alluded to here, as one pig stands on the ground, while the other is carried on the man's

shoulders. The imagery has suffered significant damage. The gilding used for the tunic of the grape-presser has flaked off revealing a sketched outline. Similarly, the pigment used for the flesh has blackened, probably due to the use of lead, which oxidizes over time. The imagery is closely related to a group of Psalters probably produced in Liège, notably a manuscript in the British Library, Additional MS 21114, which appears to have been decorated by the same artist.

BIBLIOGRAPHY

Oliver; Colker (1991).

Trinity College Library MS 600

Psalter in verse, canticles, *On the Twelve Abuses of the World* (ff. 1–51)
182 x 123 mm, 176 folios
c.1250–1300, England

This small manuscript contains a version of the Psalms in simple, rhyming, Latin verse, often much abridged. This is followed by a group of canticles based on Old Testament texts. The text is written in a Gothic book-hand of the second half of the thirteenth century. The hand combines legibility with unevenness in letter size and an inconsistent relationship with the ruled lines. The manuscript begins with a prayer in which the author asks to be made worthy to undertake his task. At the end of the Psalms he offers a justification for his work, explaining how the Psalms may be understood by different age groups, building on the long association of the Psalter with education. The simple minds of infants are stimulated by the song, while the Psalms help boys learn vocabulary, and older men may achieve sanctity through understanding the meaning. Psalms 1 to 118 include an interlinear and marginal gloss, which provides a commentary on the text. The gloss is written in a contemporary hand, but in a different ink and with a finer pen, suggesting that it was added to the original text as a separate stage of production. In this reworking of the Psalter the Psalms are explicitly interpreted as referring to Christ, with references made to Him in the text. For example, in Psalm 118:122, the words *Christe rex* ('Christ the king') have been added to the usual verse 'uphold thy servant unto good'. The author's name may have been Thomas, as in Psalm 53 he describes himself as 'Thomas, imitating Thomas', referring to the disciple who touched Christ's wounds. Each Psalm opens with a simple initial in red or blue, with a slightly more elaborate initial at the start of Psalm 1.

 In Psalm 118 the divisions provided in the original text by letters of the Hebrew alphabet are marked with alternating red and blue initials. Each section of text begins with the same word used in the Gallican version. A column has been ruled on the left for the first letter of each line. The parchment quality in this manuscript is often poor. In the

opening illustrated here a hole is visible in the margin of folio 29v, while in the margin of folio 30 a hole has been sewn up. Given the care taken over the execution of the text, the condition of the parchment suggests that the maker had limited resources available for his task. The ink used is very dark, indicating high carbon content. The manuscript was later bound with texts on English history.

BIBLIOGRAPHY

Colker (1987–8); Colker (1991); Colker (2008).

26 Trinity College Library MS 600 ff. 29v–30, Psalms 118:118–119:3. © The Board of Trinity College Dublin.

Chester Beatty Library MS W. 61

Psalter (Gallican)
162 x 110 mm, 218 folios
1265–75, Flanders

This small and lavishly decorated Psalter was a symbol of wealth and status as well as an aid to private prayer. The text is written in a particularly legible and relatively large Gothic book-hand, with minimal abbreviation, suggesting that the reader may not have been very familiar with Latin. The manuscript begins with a calendar, containing images of activities relevant to the months, followed by seven full-page miniatures on the versos of folios 7–13 that trace Christ's life from the Annunciation to the Crucifixion. On folio 14v the Beatus initial includes images of the Resurrection and the Harrowing of Hell. The imagery thus identifies the Psalms as texts about Christ. Seven other full-page images were inserted into the book as single leaves. Some of these images continue the narrative of Christ's life, depicting the *Noli me tangere* (f. 42, Psalm 26), the Incredulity of Thomas (f. 60v, Psalm 38), the Ascension (f. 77v, Psalm 52), Pentecost (f. 94v, Psalm 68) and the Last Judgement (f. 157, Psalm 109). In addition, Saints Dominic and Francis are given full-page images on folios 115v (Psalm 80) and 135v (Psalm 97) respectively. These two saints founded preaching orders early in the thirteenth century that became enormously popular because of their engagement with the lives of ordinary lay men and women. More saints appear in historiated initials, beginning with Peter at Psalm 26 (f. 41v) and Paul at Psalm 38 (f. 61). The other saints represented were all popular figures: Laurence (f. 76, Psalm 51), Stephen (f. 78, Psalm 52), Margaret (f. 95, Psalm 68), Nicholas (f. 116, Psalm 80), Martin of Tours (f. 136, Psalm 97), and John the Baptist (f. 139, Psalm 101). The initial to Psalm 109 shows the Coronation of the Virgin (f. 156v). The initials thus mark the eight-part liturgical division of the text, together with the three-part division of the Psalms. The pages with historiated initials also feature borders with grotesques, as well as animals or figures engaged in strange activities. The choice of subjects for the initials and full-page images is similar to that in a manuscript now in New York, Morgan Library MS M. 72.

On folios 60v–61 the Incredulity of Thomas faces the start of Psalm 38, which opens with an image of Saint Paul carrying the sword with which he was beheaded. The stories of both Thomas and Paul resonate with the text of the Psalm, which begins 'I said: I will take heed to my ways: that I sin not with my tongue' (*Dixi custodiam vias meas ut non delinquam in lingua mea*). Thomas famously expressed doubts about the resurrected body of Christ, declaring that he would not believe until he had seen and touched Christ's wounds, while Paul persecuted believers until his conversion. The inclusion of the images of Christ's life allows the reader to 'see' the invisible Christ, and to meditate on the Psalms as texts predicting His appearance. In the Thomas image Christ carries a cross-headed staff as a reminder of the crucifixion, with a banner symbolizing the triumph of the resurrection. The borders on the page opposite include grotesque dragons, one of which has the tonsured head of a monk, and in the lower right corner a fox attacks a rabbit reading a book. This imagery may have been inspired by the last verse on the page, which declares 'O Lord, make me know my end' (*notum fac michi domine finem meum*). The open book held by the rabbit echoes the book open before the reader, perhaps identifying reading as part of a battle against malevolent forces, albeit in an entertaining way.

BIBLIOGRAPHY

Millar Vol. 2; Dougan; Oliver; Stones.

27 (overleaf) Chester Beatty Library MS W. 61 ff. 60v–61, Psalm 38.1–5. © The Trustees of the Chester Beatty Library, Dublin.

S. PAVLVS

ixi custodiam
uias meas:
ut non delin-
quam in lin-
gua mea.
Posui ori
meo custodi-
am. cum con-
sisteret pecca-
tor aduersū
me.
Obmutui et humiliatus sum et silui
a bonis. et dolor meus renouatus est.
Concaluit cor meum intra me. et in me-
ditatione mea exardescet ignis.
Locutus sum in lingua mea: notum
fac michi domine finem meum.
Et numerum dierum meorum quis est:
ut sciam quid desit michi.

Trinity College Library MS 91

Psalter (Gallican)
185 x 130 mm, 245 folios
c.1270–80 and fourteenth century, France

In this small Psalter, designed for intimate reading, the Psalms are followed by the canticles, creed, litany and prayers. The volume was enriched in the fourteenth century with a calendar in French, executed in red, blue and gold (ff. 1–13), perhaps replacing an earlier calendar. The text is written in a clear Gothic book-hand, with minimal abbreviation, making it very easy to read, and perhaps suggesting that it was designed for someone with limited literacy. The volume has been carefully corrected; for example, an erasure of letters is visible in the final line of folio 15. The Psalter opens on folio 14 with a Beatus initial in which King David is depicted as the author of the Psalms, shown in the act of writing (see Fig. 7). The musical associations of the Psalter, however, are indicated by the presence of a figure playing a portative organ in the margin. A second marginal figure may be dancing, while the margins also contain male and female lions and a grotesque. The painted decoration continues on folios 14v–15, and the rest of the volume is decorated with penwork in red, blue and gold.

 The opening illustrated here contains the beginning of Psalm 2, which starts with a large initial Q. The tail of the letter has been turned into a winged monster that bites the circular body of the initial, and in the lower margin a lioness runs along an extension of the letter. On the following page the line fillers include an image of a woman with a heraldic shield (a field of azure with a bar d'or). This shield appears again in the line-filler five lines below, together with three other coats of arms. The female figure gestures towards the verse 'The Lord hath said to me: thou art my son, this day have I begotten thee' (*Dominus dixit ad me filius meus es tu, ego hodie genui te*). This may suggest that the Psalter was intended for a woman, and was perhaps made to celebrate a marriage or the birth of a child. The final line-filler on this page contains a head blowing a hunting horn and a hare or rabbit. This follows the verse 'And now, O ye kings,

understand: receive instruction, you that judge the earth' (*Et nunc regis intelligite erudimini qui judicatis terram*). The image may thus represent a playful interpretation of the verse, likening the trumpets of the Last Judgement (Revelation 8:6) to a hunt, and thus also referring to the pastimes of the rich.

BIBLIOGRAPHY

Colker (1991)

29 Detail of Trinity College Library MS 91, f. 15. © The Board of Trinity College Dublin.

28 (*overleaf*) Trinity College Library MS 91, ff. 14v–15, Psalm 1:3–2:11. © The Board of Trinity College Dublin.

quecumq; faciet prosperabuntur.
Non sic impii non sic: sz tanquam
pulius quem proicit uentus a fa
cie terre.
Ideo non resurgunt impii i iudicio.
neq; peccatores in consilio iustorum.
Qm nouit dominus uiam iustor ↄ iter
impior peribit.
Quare fremuerunt gentes: ↄ ipli
meditati sunt in ania.
Astiterunt reges terre ↄ principes con
uenerunt in unum: aduersus dnm
ↄ aduersus xpistum eius.
Dirumpamus uincula eorum et
piciamus a nobis iugum ipor.
Qui habitat in celis irridebit eos:

et dominus subsannabit eos.
Tunc loquetur ad eos in ira sua et in
furore suo conturbabit eos.
Ego autem constitutus sum rex ab
eo super syon montem sctm eius: p̄-
dicans preceptum eius.
Dominus dixit ad me filius meus
es tu: ego hodie genui te.
Postula a me 7 dabo tibi gentes he-
reditatem tuam: 7 possessionem tuā
terminos terre.
Reges eos in virga ferrea: 7 tanq̄
vas figuli confringes eos.
Et nunc reges intelligite: erudimi-
ni qui iudicatis terram.
Servite dño in timore: 7 exultate ei

Trinity College Library MS 11042

Ferial Psalter
126 x 96 mm, 100 folios
Fourteenth century, Germany

This manuscript is designed for use in the liturgy. The text is written clearly and legibly in a bâtarde hand. The small scale makes the volume easily transportable and indicates that it was for individual use. The manuscript would have been relatively cheap to produce, but the text is clear, structured with the addition of coloured initials, and the volume is straight-forward to use. The text area was marked out, but not ruled, resulting in a varying number of lines per page, with some pages having 18 lines of text and others up to 24. However, the start of each Psalm is marked with a large letter in red, green or blue, and the beginning of each sentence is indicated with alternating red and green letters. The Beatus initial is slightly more elaborate than the first letter of the other Psalms, incorporating both red and green pigments. The volume is now incomplete, ending in the middle of Psalm 108:27. The loss at the end of the manuscript may be the result of the binding, as the volume is now bound only in a parchment cover, which is much less sturdy than wooden boards. Johannes Mülech, a sixteenth-century owner, wrote his name on the covers. In the fifteenth century, a foliate border and new initial were added to folio 57v at the start of Psalm 68, but this is the only part of the surviving manuscript to receive such decoration.

On folios 40v–41 the end of Psalm 47 is followed by the Gloria: 'Glory be to the Father and to the Son and to the Holy Spirit' (*Gloria patri et filio et spiritui sancto*). The start of Psalm 48 (labelled as 49 by a later hand in the margin) is then marked by the word psalmus in red and a larger initial A for *Audite haec, omnes gentes*, 'Hear these things, all ye nations'.

BIBLIOGRAPHY

Sotheby's 23.6.1998; Colker (2008).

30 Trinity College Library MS 11042 ff. 40v–41, Psalms 47:9–48:15.
© The Board of Trinity College Dublin.

Trinity College Library MS 92

Psalter-Hours (Gallican)
308 x 204 mm, now 98+ii folios, but originally 156 folios
c.1390–1400, London, England

This once substantial and visually impressive volume has lost its cover and many of its pages, and parts of the contents are now not in their original order. The manuscript originally contained the texts of both the Psalter and the Hours of the Virgin, together with the Litany and other prayers. The text is written in an easily legible Gothic book-hand, although one that demonstrates a certain unevenness of placement in relation to the writing line and a lack of crispness in the basic elements of the script. It seems to have been completed by one scribe. The verses of the Psalms are marked by alternating gold and purple and red and blue penwork initials. Each Psalm begins with a fully painted initial usually containing foliate, geometric or figurative decoration, and most of the pages have foliate designs in the margins. The eight major liturgical divisions are marked by larger initials and borders that occupy all four margins at Psalms 1 (f. 11), 38 (f. 34), 51 (f. 42), 52 (f. 42v), 68 (f. 52), 97 (f. 69v), and 109 (f. 80v) with the page for Psalm 26 now lost. In addition there are historiated initials containing figures or grotesques at Psalms 20 (f. 23, see below), 21 (f. 23v, a grotesque, a male head and a female head), 22 (f. 24, a grotesque), 23 (f. 24, the globe), 24 (f. 23v, a woman kneels before an altar), 25 (f. 24v, a crawling man), 97 (f. 69v, a group of singing clerics and a king), and 109 (f. 80v, the Trinity). The volume was worked on by at least two artists, which may help to explain the distribution of the imagery. Many of the subjects represented in the initials relate to the text that follows. For example, at Psalm 109, which begins 'The Lord said to my Lord: Sit thou at my right hand: Until I make thy enemies thy footstool' (*dixit Dominus Domino meo sede a dextris meis. Donec ponam inimicos tuos scabellum pedum tuorum*), the initial includes an image of the Trinity holding the world (f. 80v), while at Psalm 29 (f. 27) a chained monkey seems to represent a humorous play on the words 'liberate me' (*libera me*). Some of the margins are enlivened with a collection of hybrids and grotesques, and the scribe may

have been responsible for some pen sketches of monstrous creatures. The manuscript is very similar in style to a group of manuscripts produced in London at the end of the fourteenth century, including the Litlyngton Missal, and a Psalter-Hours now in the National Library of Scotland, Edinburgh (MS 18.6.5) produced for Eleanor de Bohun, wife of Thomas, Duke of Gloucester (see Figs. 5–6). It is possible that the Trinity College Library manuscript was also made for someone with connections to the royal family (see the essay on Library Collections above).

A combination of imagery that is closely related to the text and marginal designs that are humorous, even satirical, can be seen on folios 22v–23. In the initial to Psalm 20, 'In thy strength, O Lord, the king shall joy; and in thy salvation he shall rejoice exceedingly' (*Domine in virtute tua laetabitur rex et super salutare tuum exultabit vehementer*), a king kneels in prayer. However, in the margins of the pages and the initial to the previous Psalm lurk monstrous creatures, including a man wearing a pair of bellows on his head, imagery that must have been designed to entertain the reader, and may also have served as satirical commentary on those prone to verbosity (see Fig. 11).

32 Detail of Trinity College Library MS 92 f. 23. © The Board of Trinity College Dublin.

31 (*overleaf*) Trinity College Library MS 92 ff. 22v–23, Psalms 18:6–20:7. © The Board of Trinity College Dublin.

BIBLIOGRAPHY

Sandler; Dennison; Colker (1991); Scott Vol. II.

ipſe tanquam ſponſus pꝛocedens de thalamo ſuo.
Exultauit ut gigas ad currendam uiam. a
ſummo celo egreſſio eius. Et occurſus eius
uſq̋ ad ſummum eius. nec eſt qui ſe abſcondat
a calore eius. Lex dñi immaculata conuertens
animas. teſtimonium dñi fidele ſapienciam pꝛeſ
tans paruulis. Iuſticie dñi recte letificantes
coꝛda. pꝛeceptum dominum lucidum illuminans
oculos. Timoꝛ dñi ſc̃s pmanet in ſc̃lm ſc̃li.
iudicia dñi uera iuſtificata inſemet ipſa. Deſi
derabilia ſup aurum ⁊ lapidem pꝛecioſum mul
tum. ⁊ dulcioꝛa ſup mel ⁊ fauum. Et enim
ſeruus tuus cuſtodit ea. in cuſtodiendis illis
retribucio multa. Delicta quis intelligit ab
occultis meis munda me. ⁊ ab alienis parce
ſeruo tuo. Si mei non fuerint dñati tunc in
maculatus ero. ⁊ emundaboꝛ a delicto maximo.
Et erunt ut complaceant eloquia oꝛis mei.
⁊ meditacio coꝛdis mei in conſpectu tuo ſemp.
Domine adiutoꝛ meus. ⁊ redemptoꝛ meus.
Exaudiat te dñs in die tribulacionis.
pꝛotegat te nomen dei iacob. Mittat
tibi auxilium de ſc̃o. ⁊ de ſyon tueat̃
te. Memoꝛ ſit omnis ſacrificij tui. ⁊ holocauſt

tum tuum pingue fiat. Tribuat tibi secun
dum cor tuum: & omne consilium tuum confirmet. Letabimur
in salutari tuo: & in noie dei nostri magnificabimur.
Impleat dominus omnes peticiones tuas.
nunc cognoui quoniam saluum fecit dominus
xpm suum. Exaudiet illum de celo sancto
suo: in potentatibus salus dextere eius. Hii in
curribus & hii in equis: nos autem in nomine
domini dei nostri inuocabimus. Ipsi obli
gati sunt & ceciderunt: nos autem surreximus
& erecti sumus. Domine saluum fac regem: &
exaudi nos in die qua inuocauerimus te.

Domine in uirtute tua letabitur rex:
& sup salutare tuum exultabit uehe
menter. Desiderium cordis eius tri
buisti ei: & uoluntate labiorum eius non frau
dasti eum. Quoniam preuenisti eum in be
nedictionibus dulcedinis: posuisti in capite eius
coronam de lapide precioso. Uitam petiit
a te & tribuisti ei: longitudinem dierum in
seculum & in seculum seculi. Magna est gloria eius
in salutari tuo: gloriam & magnum decorem i
pones super eum. Quoniam dabis eum in benedic
tionem in seculum seculi: letificabis eum in

Trinity College Library MS 69

Psalter in Latin (Gallican) and English (ff. 1–55), Apocalypse and other works
200 x 260 mm, 124 folios
*c.*1350–1400, London (?), England

This manuscript has been neatly executed, with slim margins to maximize the space available for text. The text is written as prose, in an Anglicana book-hand, and the number of lines on a page in the Psalter varies from 38 to 48. This scribe may also have written another copy of the same text in a manuscript now in Princeton University, Scheide Library MS 143. The Psalms are followed by canticles and the creed, after which there is a note declaring that this is the end of the Psalter translated into English, and naming John Hyde, who was presumably the manuscript's owner, and may also have been the scribe (*Explicit psalterium translatum in anglicum Johanni Hyde constat*). Each Latin verse is followed immediately by its Middle English translation. In addition, some glosses have been inserted into the Latin, though these are marked with an .i. (for *id est*, that is). However, the Psalm tituli are only given in Latin. This text was thus a tool for the study of the Psalms and here it is combined with other theological and moralizing material. The Psalms are followed by the Apocalypse, or Book of Revelation, together with an extract from *The Mirror*, an *Exposition on the Decalogue*, *The Seven Commandments of the New Testament*, and a *Description of Jerusalem*. To these, the fourteenth-century poem *The Pricke of Conscience* has been added. *The Pricke of Conscience* is set in two columns rather than the single block of text used for the Psalms and other texts. The emphasis on the textual content is reinforced by minimal decoration, although the start of each verse of the Psalms has been marked in red. In addition the start of each Psalm is indicated with a larger initial letter, usually occupying two lines, and the use of a yellow wash to highlight the opening words. The Beatus initial is decorated with simple penwork in the same black ink used for the text. The liturgical divisions still seem to linger in this manuscript as (in addition to the large Beatus initial for Psalm 1), Psalms 26, 68, 80, 97, and 109 are given larger initials, occupying four lines.

Although there are no marginal notes in the volume, the manuscript has been well used. Many pages are stained and smudged, and several have the remains of drops of wax indicating that the volume was sometimes read by artificial light and by someone who did not take the trouble to clean their hands. A stain is visible in the lower margin of folio 6 (illustrated here). Although space has been left for the first letter of each Psalm, the rest of the text has been written out in black ink, leaving some space around the first letter of each verse and between the Latin and English translations. The first letters of the verses have then been over-painted, often rather clumsily, in red.

33 Trinity College Library MS 69 ff. 5v–6, Psalms 14:1–17:2. © The Board of Trinity College Dublin.

BIBLIOGRAPHY

Forshall & Madden; Bülbring; Colker (1991); Hanna; Black & St-Jacques.

Trinity College Library MS 10956

Ferial Psalter
141 x 114 mm, 95 folios
c.1400, Southern France

This small Psalter was designed for personal use in the secular liturgy and has been very carefully executed. The text is written in a Gothic book-hand and set out in two columns with large initials with red, blue and purple penwork marking the start of the Psalms and smaller, alternating, red and blue initials for the start of each sentence. The penwork often extends into the margins. The most elaborate initials are reserved for liturgical divisions indicating the first Psalms sung at Matins each day and Sunday Vespers; Psalms 1 (f. 1), 26 (f. 15), 38 (f. 23v), 52 (f. 32), 68 (f. 40v), 80 (f. 50v), 97 (f. 59v) and 109 (f. 68v).

Folios 14v–15 provide an example of the information presented in this Psalter. On folio 14v is the end of Psalm 25, the last Psalm sung at the office of Prime on Sundays, which is followed by a rubric indicating the start of the office of Matins on Monday. The text begins with the invitatory antiphon taken from Psalm 94, 'Come, let us praise the Lord; let us joyfully sing to God the saviour' (*Venite exultemus domino; jubilemus Deo salutari*), executed in a smaller script. A red letter P and the repeated words Venite exultemus then indicate that the full Psalm is to be said. Returning to the larger script, the next item is a hymn that begins 'With limbs refreshed with sleep, despising our beds, we rise; we ask, Father, for your presence with us as we sing' (*Sompno refectis artubus spreto cubili surgimus, nobis pater canentibus adesse te depossimus*). After the hymn is the instruction that on Easter Monday, the antiphon 'Alleluia, alleluia' as well as the Dominus defensor should be used. On folio 15 is the start of Psalm 26, the first Psalm used at Matins on Mondays. The stain on this page is a rare sign of use in this manuscript, which has otherwise been treated with great care.

BIBLIOGRAPHY

Sotheby's 10.12.1996; Colker (2008).

34 Trinity College Library MS 10956 ff. 14v–15, Psalms 25:4–26:11.
© The Board of Trinity College Dublin.

Trinity College Library MS 93

Psalter (Gallican) and hymnal
295 x 210 mm, i + 115 folios
1450–1500, London or East Anglia, England

The coat of arms on folio 1v indicates that this manuscript was made for Sir John Wingfield and his wife Elizabeth Fitzlewis, who married in *c*.1450. The style of the work also suggests a date of production in the second half of the fifteenth century. The Wingfields lived at Letheringham in Suffolk. The text is written in an extremely formata Gothic book-hand with limited abbreviation and seems to have been executed by one scribe. The Psalms are followed by canticles and the creed. On folio 92v is the litany in which the names of the saints have been erased by a post-Reformation reader. A leaf that probably contained the names of additional saints has also been removed at this point. The volume is decorated throughout with penwork in red, blue, brown and gold. In addition, the major liturgical divisions at Psalms 26 (f. 14), 38 (f. 22v), 52 (f. 30), 80 (f. 46), 97 (f. 55), and 109 (f. 65) open with a fully painted initial, and those pages, together with the Beatus initial's page, also have borders containing foliate decoration. A page has been excised at folios 36–37, which would have contained the start of Psalm 68. The most lavish decoration is saved for the first opening, which contains a full-page image on folio 1v, while the Beatus initial on folio 2 shows David enthroned with a sceptre and harp.

 The full-page image on folio 1v contained two main scenes, framed by a border with six roundels that provided further prompts for meditation on the Psalms. Part of the image in the lower part of the page has been cut away, revealing a later owner's additions on the flyleaves, but this section probably contained an image of the three persons of the Trinity on a large throne, the remains of which are still visible. In the scene above King David stands in a fissure in the earth, watched by musicians and other figures in fifteenth-century dress. This scene occurs in a small number of fifteenth-century English Psalters (including London, Victoria & Albert Museum MS Reid 42; London, British Library, Additional MS

65100; and New York, Morgan Library M. 893), where it is also associated with the first Psalm. This imagery resonates with passages such as that in Psalm 39 in which the Psalmist rejoices that he has been rescued from the 'pit of misery'. The image is paralleled in the roundel on the right in which Jonah is vomited up by the whale, an event that was understood as a prefiguration of Christ's resurrection. The roundels at the top of the page develop the theme of triumph over evil, showing David fighting and then beheading Goliath. The image in the roundel opposite Jonah shows David enthroned as king, in a scene that probably echoed the representation of the excised enthroned Trinity below. At the bottom of folio 1v the final two roundels relate to the role of the Psalms as tools with which to praise God, showing clerics with an open book, in the act of singing the Psalms, and David playing bells (see Fig. 4).

BIBLIOGRAPHY

Colker (1991); see also Scott.

35 (*overleaf*) Trinity College Library MS 93 ff. 1v–2, Psalms 1:1–2:6. © The Board of Trinity College Dublin.

quid mamu
...is in li...
Alis q...
del ara...
quid vent...
...to vita homin...
...ter vis tillit...
nil eius dice...
quod volis...
quid mundus...
in bidel Ede...

...ma pop...
cor...at...

Beatus vir qui non abijt in consilio impiorum: et in via peccatorum non stetit: et in cathedra pestilencie non sedit. Sed in lege domini voluntas eius: et in lege eius meditabitur die ac nocte. Et erit tanquam lignum quod plantatum est secus decursus aquarum: quod fructum suum dabit in tempore suo. Et folium eius non defluet: et omnia quecumque faciet prosperabuntur. Non sic impij non sic: sed tanquam pulvis quem proijcit ventus a facie terre. Ideo non resurgunt impij in iudicio: neque peccatores in consilio iustorum. Quoniam novit dominus viam iustorum: et iter impiorum peribit.

Quare fremuerunt gentes: et populi meditati sunt inania. Astiterunt reges terre et principes convenerunt in unum: adversus dominum et adversus christum eius. Dirumpamus vincula eorum: et proijciamus a nobis iugum ipsorum. Qui habitat in celis irridebit eos: et dominus subsannabit eos. Tunc loquetur ad eos in ira sua: et in furore suo conturbabit eos. Ego autem constitutus sum rex ab eo super syon montem sanctum

Trinity College Library MS 106

Psalter and hymnal
164 x 125 mm, 177 folios
c.1450–1500, Rome (?), Italy

The small scale of this manuscript suggests that it was a personal possession. The text is written in a competent humanistic book script. Each Psalm opens with a penwork initial, except for those at the start of Psalms 1 (f. 7), 20 (f. 22v), 26 (f. 28), 32 (f. 34), 39 (f. 42v), 45 (f. 49v), 52 (f. 54v), 59 (f. 59), 68 (f. 64v), 79 (f. 76v), 85 (f. 80v), 95 (f. 88), 101 (f. 90v), 105 (f. 95v), and 109 (f. 101), which are marked by painted and gilded initials containing foliate designs that extend into the margin. These initials mark the liturgical divisions for monastic services, indicating the first Psalms used at Matins each day (Psalms 20, 32, 45, 59, 85, 101) and those used at Prime and Vespers on Sunday (Psalms 1, 109), together with those used at the night offices (nocturnes). Space was left for a painted initial at the other usual division at Psalm 73, but this was completed with a penwork initial, and moreover the wrong letter, as 'A' was substituted for 'U'. The Psalms are followed by canticles, prayers, the creed, and hymns. The scribe struggled with the layout of a Ferial Psalter. At the end of Psalm 51 on folio 54r the scribe fell afoul of the distractions presented by integrating liturgical material into the Psalter. He followed the end of Psalm 51 with a heading Psalm 52, ran a line through the heading and proceeded to write in the required lectio, but on folio 54v wrote the heading Psalm 53 with the text of Psalm 52. This is not the end of the scribe's problems with enumeration. He divides Psalms 67 and 68 so that his Psalm 72 is actually Psalm 69. Further problems are evident in the writing of the calendar, where parts of the text for April were written onto the page for June and then crossed through.

 The opening illustrated here includes the calendar page for December, complete with decorative penwork, and the opening of the Psalm text. The major feasts in the calendar, including Christmas, are identified in red. The other saints commemorated in December may indicate a connection with Rome as they include Saint Bibiana, who was

buried in a church dedicated to her in the city, Saint Sabbas, whose relics were brought to Rome in the Middle Ages and who was the dedicatee of a monastery on the Aventine Hill, and the relatively rarely celebrated Pope Miltiades. In the Beatus initial David is presented as an old man with a long, grey beard playing a psaltery. His crown is marked out on his halo, but is now difficult to distinguish. In the text the start of each verse is marked by alternating red and blue initials. The scribe has indicated the letters to be painted, and the person responsible for executing these letters has not always attempted to obscure these instructions. The degradation of the text suggests that the ink did not adhere well to the parchment, but may also indicate that the book has been well-used. Nevertheless, the largely clean and white parchment suggests that the volume has been carefully handled. The border, which has suffered from the trimming of the manuscript when it was rebound, is made up of a mass of swirling foliage and golden dots. In the lower margin is a coat of arms set within a wreath supported by two putti, a common feature of Italian books of this period.

37 Detail of Trinity College Library MS 106 ff. 6v–7, Psalm 1:1–5. © The Board of Trinity College Dublin.

36 *(overleaf)* Trinity College Library MS 106 ff. 6v–7. Psalm 1:1–5. © The Board of Trinity College Dublin.

BIBLIOGRAPHY

Colker (1991)

KL Decembr̃ h̃et dies xxxj. luna xxx.
h̃et horas. xdom̃. dies nõ. ix.

	f	Nebr.	
xiij	g	iiij nõ	S̃ce Bibiane. ℣.
ij	a	iij nõ	
x	b	ij nõ	S̃ce barbare. ℣. 7 m̃.
	c	Nonas	S̃ci Salbe ab.
xviij	d	viij id̃	S̃ci Nicolai epĩ. 7 oft.
vij	e	vij id̃	S̃ci Ambrosij epĩ. 7 oft. 7 doct.
	f	vj id̃	Ɫ̃ceptio sc̃e marie. ℣.
xv	g	v id̃	
iiij	a	iiij id̃	S̃ci melchiadis. pp. 7 m̃.
	b	iij id̃	S̃ci Damasi. pp. 7 m̃.
xij	c	ij id̃	
j	d	Idus	S̃ce lucie. ℣. 7 m̃.
	e	xix	kł Januarij
ix	f	xviij	
	g	xvij	
xvij	a	xvj	
vj	b	xv	
	c	xiiij	
xiiij	d	xiij	
iij	e	xij	S̃ci thome apĩ
	f	xj	
xj	g	x	
xix	a	ix	
	b	viij	Nativitas dñi nr̃i. ℣ḃñ x.
viij	c	vij	S̃ci Stephani pt̃om̃.
	d	vj	S̃ci Joh̃is apl̃i 7 euang.
xvj	e	v	Sc̃oꝝ Innocentum.
v	f	iiij	S̃ci thome archiepĩ. 7 m̃.
	g	iij	
xiij	a	ij	S̃ci Silvestri. pp. 7 m̃.

ntiphona. Secundo tono i tuore. psalmus.

B
eatus vir qui non abi-
it in consilio im-
piorum: et in via
peccatorum non
stetit: et in cathe-
dra pestilentie non
sedit. Sed in
lege dni fuit
uoluntas eius:
et in lege eius meditabitur die ac nocte.
Et erit tanquam lignum qd plantatum
est secus decursus aquarum: qd fructum
suum dabit in tempore suo. Et folium
eius non defluet: et omnia quecunque fa-
ciet prosperabuntur. Non sic impij non
sic: sed tanquam pulvis quem proicit
uentus a facie terre. Ideo non resurgunt
impij in iudicio: neque peccatores in consi-

Glossary

Anglicana: English Gothic documentary script increasingly used, in a more formal version, as a vernacular book-hand from 1350.

Antiphon: a verse, or verses, recited before and after Psalms during parts of the liturgy.

Bâtarde: a Gothic script that developed during the fourteenth century.

Beatus initial: the initial letter at the start of Psalm 1, for the word 'beatus' (blessed). This initial is often lavishly decorated as it marks the start of the text.

Bifolio: a sheet typically of parchment or paper folded in half to produce two folios. Using folded bifolios helps to provide stability and prevent folios from becoming detached from the manuscript.

Canticle: literally a 'little song', scriptural hymns used in the liturgy, perhaps the two best known being the 'Magnificat' (Canticle of the Virgin Mary, Luke 1:46–55) and the 'Nunc Dimittis' (Canticle of Simeon, Luke 2:29–32). Canticles are sometimes included in Pslaters after Psalm 150.

Caroline: a minuscule script developed at the end of the eighth century, characterized by roundness and clarity of form. It is the basis of modern lower case type.

Creed: the statement of belief for Christians. Three major creeds were used during the Middle Ages: the Apostles', Nicean and Athanasian. One or more of these texts may be included in Psalters, typically after the Psalms.

Ferial Psalter: also known as a Choir Psalter or a Liturgical Psalter, these volumes provide additional material to help the reader use the Psalms within the daily services.

Folio: from the Latin for 'leaf', a double-sided surface (typically of parchment) for writing or decoration in a book. The front of the leaf is known as the recto (r), and the back as the verso (v). Folio may be abbreviated as 'f'.

Formata: a hand in which each letter is made stroke by stroke with a pen lift between each.

Gallican Psalter: a translation of the Psalter from Greek texts made by Jerome *c*.386–91.

Gathering: a collection of folios, typically bifolios folded in half and sewn down the fold to produce a booklet. Using four bifolios to produce a gathering of eight folios (or sixteen pages) was popular, but gatherings can have any number of folios. Also known as a quire.

Gothic book-hand: develops organically from Caroline; it is a more compressed script, oval and pointed where Caroline is round.

Hand: an individual's realization of a script.

Hebraicum Psalter: a translation of the Psalter from Hebrew texts made by Jerome *c*.392.

Historiated initial: imagery of recognizable figures or a scene within a letter form. The content is often related to the subject of the text.

Humanist script: a rounded script developed from Caroline miniscule, which was wrongly assumed by early humanists to represent a Roman imperial book-hand.

Invitatory: part of a psalm used at the start of the Divine Office as an invitation to come to worship.

Line filler: decoration used to fill space left at the end of a line of text.

Majuscule: a script written between two lines with no part of a letter reaching above or below; modern uppercase letters.

Minuscule: a script using ascenders (as in h) and descenders (as in p) to distinguish letters; in type 'lowercase' letters.

Opening: the two pages visible when a manuscript is open. The page on the right is the recto of a folio, and the page on the left is the verso of the previous folio.

Parchment: animal skin that has been stretched and scraped to provide a support for writing and decoration.

Roman Psalter (Romanum): Jerome's first revision of the Latin Psalter produced *c.*383.

Script: a set of stable letter shapes with characteristic qualities of basic formation, e.g. Caroline, Anglicana.

Tituli: 'titles' added to the Psalms to identify their author or subject. These exist in many versions.

Vulgate: a translation of the Bible into Latin by Jerome, completed in the early fifth century. This became the standard Bible of the church in western Europe.

Bibliography

T.K. Abbott, *Catalogue of the Manuscripts in the Library of Trinity College, Dublin* (Dublin, 1900).

J.J.G. Alexander, *Insular Manuscripts 6th to the 9th Century* (London, 1978).

J.J.G. Alexander, *Medieval Illuminators and Their Methods of Work* (New Haven & London, 1992).

A. Andreoppoulos, A. Casiday & C. Harrison (eds), *Meditations of the Heart: The Psalms in Early Christian Thought and Practice*, Studia Traditionis Theologiae 8 (Turnhout, 2011).

T.C. Barnard, 'The Purchase of Archbishop Ussher's Library in 1657', *Long Room*, 4 (1971), pp 9–14.

P. Binksi & S. Panayotova (eds), *The Cambridge Illuminations: Ten Centuries of Book Production in the Medieval West* (Cambridge, 2005).

R.R. Black & R. St-Jacques (eds), *The Middle English Glossed Prose Psalter*, 2 vols (Heidelberg, 2012).

E. Boran, 'The Libraries of Luke Challoner and James Ussher, 1595–1608' in H. Robinson-Hammerstein (ed.), *European Universities in the Age of Reformation and Counter Reformation* (Dublin, 1998), pp 75–115.

E. Boran, 'An Early Friendship Network of James Ussher, Archbishop of Armagh, 1626–1656' 1608' in H. Robinson-Hammerstein (ed.), *European Universities in the Age of Reformation and Counter Reformation* (Dublin, 1998), pp 116–134.

M. Brown, *Understanding Illuminated Manuscripts: A Guide to Technical Terms* (London, 1994).

K.D. Bülbring, *The Earliest Complete English Prose Psalter* (London, 1891).

J. Carney (trans.), *Medieval Irish Lyrics* (Berkeley & Los Angeles, 1967).

B. Cassidy & R.M. Wright, *Studies in the Illustration of the Psalter* (Stamford, 2000).

M.L. Colker, 'A Christianized Latin Psalter in Rhythmic Verse', *Sacris Erudiri*, 30 (1987–8), pp 329–408.

M.L. Colker, *Trinity College Library Dublin: Descriptive Catalogue of the Mediaeval and Renaissance Latin Manuscripts*, 2 vols (Aldershot, 1991).

M.L. Colker, *Trinity College Library Dublin: Descriptive Catalogue of the Mediaeval and Renaissance Latin Manuscripts: Supplement One* (Dublin, 2008).

P.R. Davies, G.J. Brooke & P.R. Callaway, *The Complete World of the Dead Sea Scrolls* (London, 2002).

L. Dennison, 'The Stylistic Sources, Dating and Development of the Bohun Workshop ca. 1340–1400' (PhD, University of London, 1988).

N. van Deusen (ed.), *The Place of the Psalms in the Intellectual Culture of the Middle Ages* (Albany, 1999).

R.O. Dougan, *Western Illuminated Manuscripts from the Library of Sir Chester Beatty Exhibited in the Library of Trinity College Dublin* (Dublin, 1955).

E. Duffy, *Marking the Hours: English People and their Prayers, 1240–1570* (New Haven & London, 2011).

N. Edwards, '11th-Century Welsh Illuminated Manuscripts: The Nature of the Irish Connection' in C. Bourke (ed.), *From the Isles of the North: Early Medieval Art in Ireland and Britain* (Belfast, 1995), pp 147–55.

J. Forshall & F. Madden, *The Holy Bible, Containing the Old and New Testaments with the Apocryphal Books, in the Earliest English Versions Made from the Latin Vulgate by John Wycliffe and his Followers*, vol. 1 (Oxford, 1850).

P. Fox (ed.), *Treasures of the Library: Trinity College Dublin* (Dublin, 1986).

R. Gameson, 'The Cost of the Codex Amiatinus', *Notes and Queries*, 237 (1992), pp 2–9.

R. Hanna, 'Notes on some Trinity College Dublin Manuscripts' in A.M. D'Arcy and A.J. Fletcher (eds), *Studies in Late Medieval and Early Renaissance Texts in Honour of John Scattergood* (Dublin, 2005), pp 171–80.

C. de Hamel, *Scribes and Illuminators* (London, 1992).

R.J. Hayes, 'Sir A. Chester Beatty and His Library', *The Princeton University Library Chronicle*, 28 (1967), pp 141–9.

A. Heimann, 'A Twelfth-Century Manuscript from Winchcombe and Its Illustrations. Dublin, Trinity College, MS. 53', *Journal of the Warburg and Courtauld Institutes*, 28 (1965), pp 86–109.

F. Henry & G. Marsh-Micheli, *Studies in Early Christian and Medieval Irish Art: Vol. II: Manuscript Illumination* (London, 1984).

A. Hughes, *Medieval Manuscripts for Mass and Office: A Guide to their Organization and Terminology* (Toronto, 1982, repr. 2004).

T.W. Jones, *A True Relation of the Life and Death of the Right Reverend Father in God William Bedell* (London, 1872).

C.M. Kauffmann, *Romanesque Manuscripts, 1066–1190* (London, 1975).

C.M. Kauffmann, *Biblical Imagery in Medieval England: 700–1550* (London & Turnhout, 2003).

J.L. Kugel & R.A. Greer, *Early Biblical Interpretation* (Philadelphia, 1986).

D.J. Ladoucer, *The Latin Psalter: Introduction, Selected Text and Commentary* (London, 2005).

M. Lapidge, 'Anglo-Latin Literature' in S.B. Greenfield & D.G. Calder (eds), *A New Critical History of Old English Literature* (New York and London, 1986), pp 5–37.

H.J. Lawlor (ed.), *The Psalter and Martyrology of Ricemarch* (London, 1914).

M. MacNamara, *The Psalms in the Early Irish Church* (Sheffield, 2000).

N.F. Marcos, *The Septuagint in Context: Introduction to the Greek Version of the Bible* (trans.) W.G.E. Watson (Atlanta, 2000).

D. McKitterick, 'The Eadwine Psalter Rediscovered' in M.T. Gibson, T.A. Heslop & R.W. Pfaff (eds), *The Eadwine Psalter: Text, Image, and Monastic Culture on Twelfth-Century Canterbury* (University Park, 1992), pp 195–208.

E.G. Millar, *The Library of A. Chester Beatty: A Descriptive Catalogue of the Western Manuscripts*, 2 vols (Oxford, 1927).

J.H. Oliver, *Gothic Manuscript Illumination in the Diocese of Liège* (Leuven, 1988).

W. O'Sullivan, 'Introduction to the Collections' in M.L. Colker, *Trinity College Library Dublin: Descriptive Catalogue of the Mediaeval and Renaissance Latin Manuscripts* 1 (Aldershot, 1991), pp 21–46.

W.E. Plater & H.J. White, *A Grammar of the Vulgate* (Oxford, 1926).

L.F. Sandler, *Gothic Manuscripts: 1285–1385*, 2 vols (London, 1986).

K.L. Scott, *Later Gothic Manuscripts: 1390–1490*, 2 vols (London, 1996).

V. Sekules, *Medieval Art* (Oxford, 2001).

G.O. Simms, *The Psalms in the Days of Saint Columba: The Story of the Cathach 'the Battle Psalter'* (Dublin, 1963).

B. Smalley, *The Bible in the Middle Ages*, 3rd edition (Oxford, 1983).

A. Stones, 'The Full-Page Miniatures of the Psalter-Hours New York, PML, MS M. 729: Programme and Patron, with a Table for the Distribution of Full-Page Miniatures within the Text in Some Thirteenth-Century Psalters' in F.O. Büttner (ed.), *The Illuminated Psalter: Studies in the Content, Purpose and Placement of its Images* (Turnhout, 2004), pp 281–307.

H. Swarzenski, *Die Lateinischen Illuminierten Handschriften des XIII Jahrhunderts* (Berlin, 1936).

J.W. Thompson, *Literacy of the Laity in the Middle Ages* (Berkeley, 1947).

R. Weber (ed.), *Biblia Sacra Iuxta Vulgatam Versionem*, 4th edition emended (Stuttgart, 1994).

R. Weber (ed.), *Le Psautier Romain et les autres anciens psautiers Latins* (Vatican City, 1953).

A. Worm, "'Du solt wizzen daz davit disen salme tihte. Und daz gotesdinst da mit rihte." Übrlegungen zu Augsburger Psalterhandschriften des 13. Jahrhundert' in M. Kaufhold (ed.), *Städtische Kultur im mittelalterlichen Augsburg* (Augsburg: Wissner Verlag, 2012), pp 18–51.

Maggs Bros., *Illuminated Manuscripts and Miniatures*, No. 404 (London, 1921).

SALE CATALOGUES

Catalogue of the Renowned Collection of Western Manuscripts the Property of A. Chester Beatty Esq.: The First Portion, Sotheby's Sale Catalogue 7.6.1932.

Catalogue of the Renowned Collection of Western Manuscripts the Property of A. Chester Beatty Esq.: The Second Portion, Sotheby's Sale Catalogue 9.5.1933.

The Chester Beatty Western Manuscripts: Part One, Sotheby's Sale Catalogue, 3.12.1968.

The Chester Beatty Western Manuscripts: Part Two, Sotheby's Sale Catalogue, 24.6.1969.

Western Manuscripts and Miniatures, Sotheby's Sale Catalogue, 10.12.1996.

Western Manuscripts and Miniatures, Sotheby's Sale Catalogue, 23.6.1998.